the KODAK Workshop Series

Electronic Flash

Written for Kodak by Lester Lefkowitz

the KODAK Workshop Series

Helping to expand your understanding of photography

Electronic Flash

Written and revised for Kodak by Lester Lefkowitz.

Kodak Editor: Martin L. Taylor

Book Design: Quarto Marketing Ltd.,
15 W. 26th St.
New York, New York 10010

Designed by Roger Pring

Illustrations by freelance photographers Steve Labuzetta,
John Meyers, and Jerry Antos, and Kodak staff photographers
Donald Buck, John Menihan, and Bob Clemens. Exceptions are
found on the following pages:

Page 6, Tom McCarthy
Page 21, Roy Morsch
Page 88, Kathe Losapio

Photographic Products Group
Eastman Kodak Company
Rochester, New York 14650

KODAK Publication KW-12
CAT 143 9850
Library of Congress Catalog Card Number 81-67431
ISBN 0-87985-372-7

10-86 BX Major Revision
Printed in the United States of America

*The Kodak materials described in this book are available from those
photographic dealers normally supplying Kodak products. Other materials
may be used, but equivalent results may not be obtained.*

KODAK, EKTACHROME, KODACHROME, KODACOLOR, VR, VR-G,
and WRATTEN are trademarks.

Contents

SOME HELPFUL DEFINITIONS

AMBIENT LIGHT: the existing light, *not* the flash illumination. Ambient light is often a combination of natural and artificial (tungsten, fluorescent, etc.) sources. Indoors, a flash usually overpowers the ambient light, so that the picture appears to have been taken by the light of the flash alone. If the ambient light is fairly strong, flash can be used as a source to fill in shadow areas. (See **FILL-IN FLASH**.)

ASA: former designation indicating the relative speed (sensitivity to light) of film. See new designation, **ISO** below.

APERTURE: the opening in a camera lens that permits light to pass through to the film. The size of the aperture is controlled by a continuously variable iris diaphragm whose size is indicated by a numerical scale called "f-stops". Low number f-stops, such as f/2 and f/2.8, indicate large apertures, which pass large amounts of light; high numbers (f/11, f/16) are small apertures which pass very little light. Each f-stop lets through half (or twice) as much light as the preceding stop; half as much if the f-numbers go up, twice as much if the f-numbers go down. You may set your lens between f-stops.

AUTOMATIC FLASH: a system that incorporates an electronic light **sensor** designed to produce proper flash exposures. Over a broad range of flash-to-subject distances, that sensor controls the amount of light generated by the flash. Unlike manual flash, with automatic flash there is no need to change the lens aperture every time the flash-to-subject distance changes.

BCPS: stands for **B**ulb-**C**andle**p**ower-**S**econds, a scientific unit of light measurement. Many flash manufacturers specify the effective light output of their equipment by listing a BCPS rating, which is useful for comparing the relative brightness of different equipment.

BEAM SPREAD: the angle of the light beam that emanates from a flash. For proper illumination with direct flash, the beam spread must be at least as wide as the angle of view of the camera lens. All flash units have a beam spread at least 45 degrees wide, which matches the angle of view of a normal camera lens. When wide-angle camera lenses are used, special attachments over the flash are usually required to increase the beam spread.

BOUNCE FLASH: rather than pointing the flash directly at the subject, the flash is aimed at a (usually white) ceiling, wall, umbrella, or sheet of cardboard. From the reflector the light *bounces* to the subject. Because of the large size of the patch of light emanating from the bounce surface (far larger than the relatively small size of the flash head itself), the quality of illumination on the subject is very soft and even.

CONFIDENCE LIGHT: Some automatic flash units are equipped with a small indicator light that signals whether sufficient light has reached the subject for proper exposure. Unfortunately they also give a "sufficient" indication even if the flash is *too* bright.

COVERING POWER:
see **BEAM SPREAD**

DEDICATED FLASH: A dedicated flash is designed to work with a specific camera; the camera, in turn, must be designed for use with a flash "dedicated" to that particular camera. In addition to providing automatic flash exposure control, a dedicated flash will automatically set the camera shutter to the proper sync speed, and light an indicator in the camera's viewfinder when the flash has recycled.

DEPTH OF FIELD: the total distance in front of and behind the actual point your camera is focused upon that appears sharp. Large lens apertures produce less depth of field than small apertures, and there is less depth of field when you are close to the subject than when you are farther away.

DIRECT FLASH: the flash is aimed directly at the subject.

FILL-IN-FLASH: Rather than providing the entire illumination, flash can be used as a supplement to the AMBIENT LIGHT. This balance between natural and flash illumination is called *fill-in* flash because the flash is generally used to fill in the dark shadow areas of the ambient-light scene. Fill-in flash is primarily used outdoors.

FLASH METER: a handheld light meter used to measure the amount of light produced by electronic flash, and to then indicate the f-stop required for correct exposure. A flash meter is particularly useful for advanced flash techniques such as multiple flash and bounce flash.

f-STOP: see **APERTURE**

GUIDE NUMBER: used to determine exposure for direct flash when the flash unit is set on manual. Dividing the guide number by the flash-to-subject distance gives the proper lens f-stop to use for that distance. The guide number is dependent on the flash unit's design and on the film speed, and is listed in the flash instruction manual. Most flash units have a scale that does the division for you. Guide numbers are also used to compare the relative power of different equipment; the higher the guide number, the more powerful the flash.

HOT SHOE: the flash "shoe" is the fitting on the camera body that holds a small portable flash. Most shoes have an electrical contact that aligns with the contact on the flash unit's "foot." When electricity flows between the contacts (when the circuit becomes "hot"), the flash fires. If the hot shoe has more than one contact pin, the camera may be used with a dedicated flash. Some cameras and many light stands and brackets have "cold" shoes; these have no electrical contacts.

ISO: ISO numbers (formerly **ASA**) indicate the relative sensitivity of film to light. The higher the film's ISO number, the more sensitive it is to light. A film with an ISO number twice as high as that of another film is twice as sensitive to light. Films with high ISO numbers (usually 200 and above) are referred to as "fast" films. For *automatic* operation of a flash, the film ISO speed must be set on the flash, and for dedicated systems, set on the camera, also.

MANUAL FLASH: flash exposure is controlled by the photographer, *not* by a sensor on the flash or in the camera. When in *manual* mode, the flash puts out a consistent, fixed amount of light; exposure (which lens aperture to use) is then determined using either the guide number or a flash meter. (Also see **AUTOMATIC FLASH**.)

MODE: Most automatic flash units may be set to give proper exposure at a number of different lens apertures. These settings are modes. Each mode is indicated by a color, letter or symbol.

NICAD: an abbreviation for "nickel-cadmium" battery. These are rechargeable batteries that are popular for flash photography. They may be recharged numerous times, and recycle the flash about twice as fast as conventional batteries.

OPEN FLASH BUTTON: a switch on the flash that allows it to be fired without pressing the camera's shutter release. It is useful for testing, determining exposure with a flash meter, and for special multiple flash effects. (Also called a **TEST BUTTON**).

OTF FLASH: Some cameras designed for dedicated automatic flash systems have a sensor inside the camera body. If it is an OTF system, flash illumination reflects from the subject, goes through the lens, then strikes the film where it reflects *off-the-film* (OTF) and into the automatic sensor. Such automatic flash systems that read the light coming through-the-lens (TTL) are particularly useful for close-up photography or work with long telephoto lenses.

PC: designates the type of connection for flash synchronization cords found on almost all cameras. A PC-cord (also called a sync cord) plugs into the camera's PC outlet and goes to the flash; the flash may be placed anywhere if the PC cord is sufficiently long. If the flash is installed in the camera's hot shoe, a PC cord is usually unnecessary. (PC stands for Prontor-Compur, the first brands of shutters to have this style of connector.)

READY LIGHT: indicates when the flash is fully charged and ready to take another picture. On most consumer-type flash equipment, the ready light comes on when the unit is only about 75% charged. If you are photographing a distant subject, using bounce flash, or have set a small lens aperture—situations usually requiring a full charge—wait a few seconds after the ready light comes on before taking the picture.

RECYCLE TIME: the time required for the flash to recharge between pictures. For a given flash unit, recycling time depends on battery type (e.g., Alkaline batteries are slower than NICADS.), battery condition, and, for direct flash pictures in automatic mode, distance of subject from flash.

SENSOR: an electric "eye" that controls the flash when it is in automatic mode. The sensor measures the amount of light reflecting back from the subject, and turns the flash off when exposure is correct for the lens aperture and film speed being used.

SLAVE: an electric eye that triggers a second flash to fire simultaneously and in exact synchronization with the primary flash. The slave (sometimes called a "slave trigger") senses the burst of light from the first flash; (or third or fourth flash, etc.). Slaves are generally used with all the flash units set on MANUAL.

STROBE: a term often used interchangeably with "electronic flash," particularly when referring to big, studio-type equipment. More properly, a *strobe* is a flash that fires a few times per second over an extended period of time.

SYNC CORD: the cord that goes between the camera's PC outlet and the flash. It carries the signal that triggers the flash to go off in *synchronization* with the opening of the camera shutter. If the flash is mounted in the camera's hot shoe, a sync cord is unnecessary.

SYNC OUTLET: see **PC** outlet.

SYNC SPEED: the speed at which the camera's shutter must be set to ensure proper *synchronization* between the flash and shutter opening. For most cameras with interchangeable lenses, the sync speed is typically 1/60 or 1/125 sec. Setting the shutter *faster* than the sync speed will result in either underexposure or a portion of the picture being black. For special effects, any shutter speed *slower* than the sync speed may be used.

THYRISTOR: part of the electrical circuitry in modern, automatic flash units. When used in automatic mode, a flash frequently need *not* put out full power, e.g., when the subject is at moderate or close distances. Under such circumstances, thyristor circuitry saves the portion of the flash charge not required for the current picture, making it available for the next shot. This increases battery life and decreases recycle time.

TTL FLASH: see **OTF FLASH**

WATT-SECOND: a unit of measure indicating the total electrical charge stored in the flash. It is frequently used as a power rating for large, studio-type flash equipment. A more useful indication of the actual amount of light reaching the subject is the flash unit's guide number, or BCPS rating.

X-SYNC: the electrical synchronization inside a camera that triggers the electronic ("X") flash to fire when the shutter is fully open. Older cameras may also have M-sync, designed for medium-peak flash bulbs, or FP-sync for focal-plane bulbs. Do not use electronic flash on M or FP sync.

ZOOM HEAD: A built-in feature on some flash units that permits the angle of the beam of light to be increased or decreased to match the angle of view of various camera lenses (wide-angle, normal, telephoto). (See **BEAM SPREAD.**) If a zoom head is not built in, most flash equipment accepts accessory add-on lenses to alter the beam angle.

Flash can do it!

Flash! Bright light! Or perhaps the sudden illumination of an idea. Which is what flash photography is all about. By adding an electronic flash unit to your photo equipment you can bring your own light to the subject. Most flash units are lightweight, inexpensive, and powerful. They allow you to brighten almost any subject with total disregard for the ambient light. Moreover, the duration of the flash is short enough to freeze fast-moving subjects. And since you control the direction, quantity, and quality of the scene lighting, you can practically guarantee the results you want. *Action! (See page 90.)*

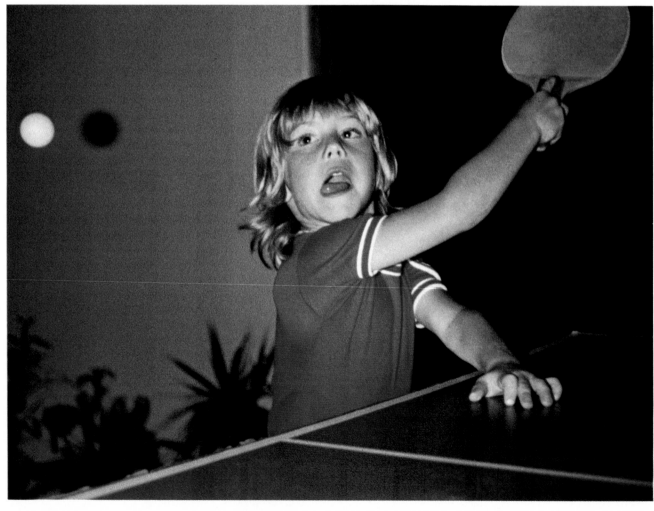

Bounced from a white card, wall or ceiling, flash can provide a soft, directional illumination. (See pages 48-54 for bounce flash.)

By using two or more flash units, each aimed at the subject from a different angle, you can achieve both high brightness and strong, dramatic effects. (See pages 62-71.).

When facing the shadow side of a subject outdoors in daylight, use your flash to brighten the deep shadows. (See page 73 for fill-in flash.)

Attach an acetate color filter to the flash to get unusual effects for nearby subjects and normal colors in the background. (See page 82 for flash with filters.)

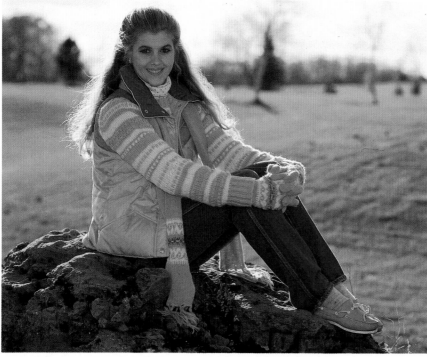

Opposite: Multiple flash is frequently used for formal photographs of people. Here four flash units create a fine studio portrait. One flash was aimed at the background, one at the model's hair and two were bounced into separate umbrellas to provide the primary illumination. (See pages 62-71).

Keeping the shutter open but covered between flashes, fire your flash several times in darkness to create intriguing images.

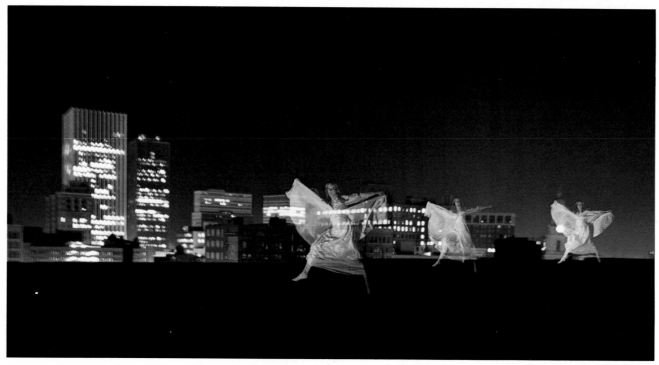

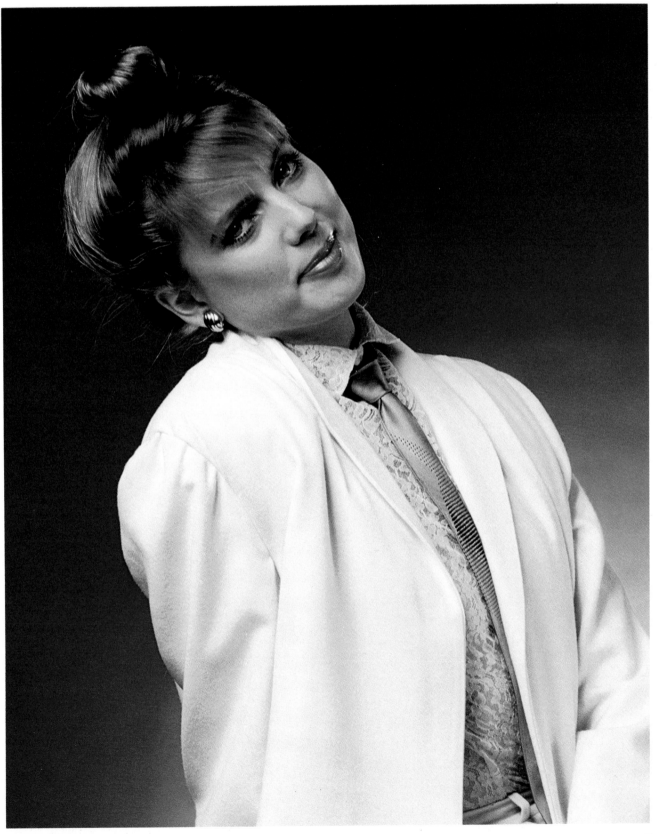

How electronic flash works

*You press the shutter release and for an instant, all is bright.
Although taking flash pictures is relatively simple, the technology
is sophisticated. Knowledge of how electronic flash functions can
help you appreciate the power, speed, and flexibility of your unit.
Understanding the limitations may improve your results.*

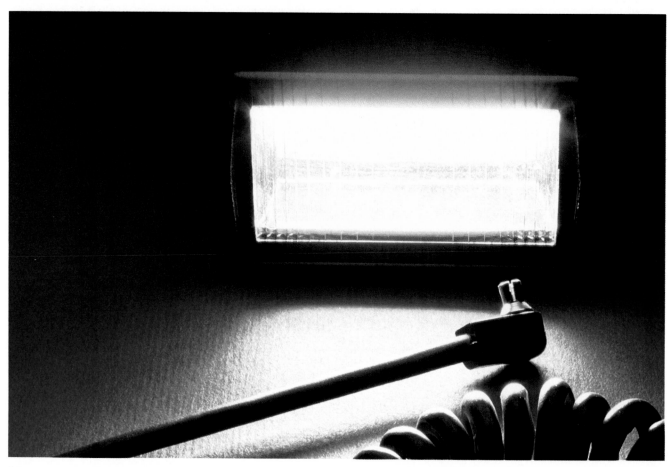

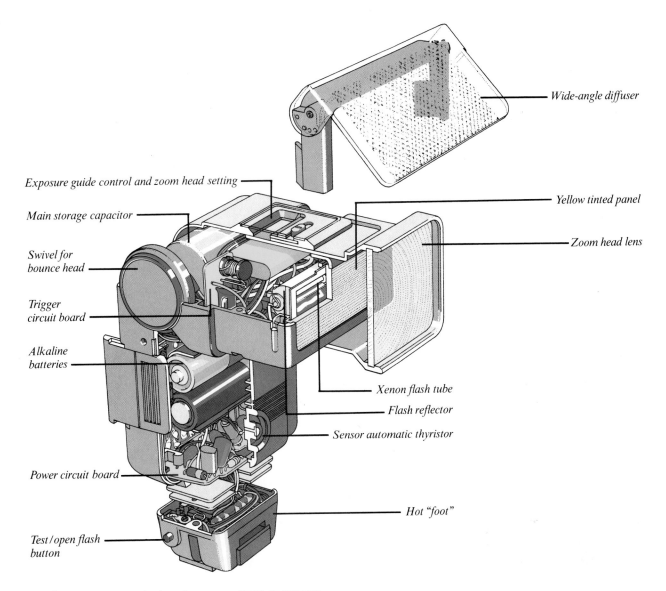

Wide-angle diffuser

Exposure guide control and zoom head setting

Main storage capacitor

Swivel for bounce head

Trigger circuit board

Alkaline batteries

Power circuit board

Test/open flash button

Yellow tinted panel

Zoom head lens

Xenon flash tube

Flash reflector

Sensor automatic thyristor

Hot "foot"

Despite the unnerving complexity of a flash unit's innards, modern-day flash is easy to use, sophisticated, and versatile. Automatic units even give exposure assistance. When the flash is fired, a high-voltage spark jumps the length of the tube, causing the xenon gas inside the tube to glow brightly (but briefly).

HOW IT WORKS

Most electronic flash units consist of a flash tube set into a reflector, batteries, and electrical circuits that enable the flash to go off on command. Also, there is an oscillator that converts the low voltage of the batteries to a much higher voltage (typically 450 volts), and a capacitor that accumulates and holds that high-voltage electricity.

Additionally, on automatic units, internal electronics can control the power output of the flash in response to a sensor that measures the flash light reflecting back from the subject. Such sensors are found on the front of the flash, or may be inside the camera

and electronically connected to the flash.

When you trip the camera shutter, a switch in the camera simultaneously fires the flash. At that moment, electrical energy stored in the flash unit capacitor is released in a sudden burst of power through the flash tube, creating a flash of light.

The flash tube has an extremely long life expectancy. It can fire thousands of bursts before wearing out. Its burst of intense light is so short (usually 1/1,000 of a second or faster) that fast action can be frozen easily in most picture-taking situations.

FLASH PHOTOGRAPHY DEPENDS ON DISTANCE

When we photograph with available light, camera-to-subject distance is a concern only in regard to focusing and composition; it has no bearing on the amount of light that reaches the film, and therefore does not affect the lens opening or shutter settings.

In flash photography, subject distance—or, more accurately, flash-to-subject distance—is a much more significant factor. Distance must always be considered when taking flash pictures because of the way light propagates. The burst of light generated by the flash unit immediately begins to spread out as it leaves the flash tube. The farther it travels, the more it spreads out and the more its intensity decreases. When the subject is near the flash, the light has not spread out very much and is therefore very bright; in fact under some circumstances, it may be too bright. Conversely, a distant subject will receive much dimmer light from the same flash.

As a consequence of this, when the flash is set on *manual,* you must set the lens to an aperture appropriate for the light level found at *each* flash-to-subject distance. With *automatic* flash, each lens aperture automatically produces correctly exposed flash pictures, but only over a prescribed range of distances. As you change apertures, the near and far limits of that range shift.

While this may sound somewhat complicated, it is extremely easy in practice. In most cases, all necessary information is right on the flash, and absolutely no calculations are required.

With direct flash—the flash pointed directly at the subject—foreground subjects often receive too much light, **top,** while those in the background too little. By placing the subjects so they are all approximately the same distance from the flash, this problem can be avoided, **bottom.** Bounce flash would be another alternative to provide more even illumination for a scene that has considerable front-to-back depth.

MANUAL FLASH

When you operate your flash in its *manual* mode, it puts out the same amount of light, for the same duration, each time it is fired. With most flash units, that amount of light is also the maximum of which the equipment is capable. (On some models, you can set the power in manual mode to $^1/_2$, $^1/_4$, and less, of maximum.)

In manual mode, you must use a *different* lens aperture for each flash-to-subject distance. How you select the correct aperture is explained on page 24.

Manual operation of a flash is ap-propriate 1) when you wish to exceed the distance limits available with automatic exposure; 2) when you feel the automatic sensor may produce erroneous exposures due to unusual subject tone or placement; 3) when the flash is removed from the camera for indirect, side-, or backlighting and the automatic sensor cannot be placed near the camera lens; or 4) when you are using more than one flash unit that is not designed for automatic, multiple flash operation. Of course manual operation is required with most studio size flash equipment and other units that do not have automatic sensors.

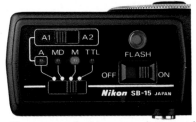

To use your flash on manual, it must be set to "M." If it has no "M" setting, it is either totally manual and lacks an automatic mode, or is totally automatic and lacks a manual mode. Check the instructions.

This picture was taken with the flash set on manual, and at a flash-to-subject distance of only 4 ft. The lens aperture was at f/22, a small opening.

With the same film, flash, and camera, the photographer moved back to 12 ft. Since the light intensity decreased with distance, a larger lens opening, in this case f/8, was required. Note that both the near and far pictures are properly exposed.

AUTOMATIC FLASH (Sensor on Flash)

The automatic mode controls the duration of the burst of light with a sensor on the flash. When the flash is close to your subject, the subject quickly receives sufficient light, and the automatic sensor turns off the flash very rapidly, typically 1/5,000 to 1/30,000 of a second, depending on distance. At longer distances, the flash remains on longer, typically 1/1,000 to 1/5,000 of a second, to compensate for less intense light reaching the subject.

Within a range of distances, then, by adjusting the duration of the flash, the automatic sensor keeps the illumination at the subject constant so there is no need to vary the aperture. This is the great advantage of automatic flash over manual flash.

You can, for example, take pictures from 5 to 12 feet in a typical situation without making any adjustments!

Automatic Sensor

A flash that can operate in the "Automatic" mode has a light sensor on the front of the unit. Light emanating from the flash reflects off the subject and returns to the general area of the camera. In the automatic mode, the sensor on the flash reads that returning light and cuts off the flash when enough illumination has been provided for adequate exposure.

Both photographs above—one taken from 5 ft, the other from 12 ft—were exposed with the flash set on automatic mode. Therefore the same aperture, f/8, could be used. In fact, for the flash unit and film combination selected here, we would get properly exposed pictures at any distance between 5 and 12 ft without adjusting the lens opening from its f/8 setting.

5.6

The viewfinders of cameras having dedicated flash capability show various amounts of flash-related information when the appropriate dedicated flash is used. In this example the red LED indicated that the camera has automatically chosen the correct shutter speed for flash synchronization, and the green "lightning-bolt" blinks when the flash has recycled.

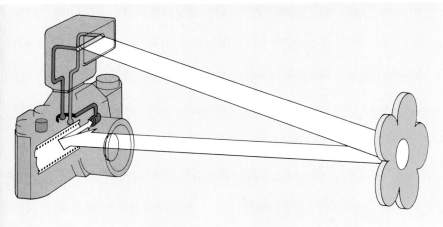

While camera manufacturers produce dedicated flash equipment for their own dedicated flash cameras, many independent flash manufacturers also offer dedicated equipment. Camera/flash compatibility is achieved with the independent brands through a system of interchangeable, dedicated modules that clip onto the body of the flash. If you change camera models, just purchase an appropriate module.

With dedicated flash systems that use a sensor in the camera, flash illumination is measured from light that passes through the lens. In most cases, the sensor reads the light after it reflects off the film. When enough illumination has been provided for adequate exposure, a signal is sent to the flash unit to cut off the light.

DEDICATED FLASH

Another version of automatic electronic flash works in conjunction with many of the latest model 35 mm cameras. These are the so-called dedicated systems. Dedicated flash is designed to work with *particular* model cameras, hence the name, and they provide one or more features beyond the automatic exposure control provided by automatic, but not dedicated, equipment.

The most basic dedicated systems automatically set the correct shutter speed on the camera when the flash is attached. They also provide a visual indicator in the camera's viewfinder to signal when the flash has recycled and is ready to fire. However, they still use the sensor on the flash for exposure control.

In addition to these two features, more sophisticated dedicated flash-camera combinations control exposure through a sensor located behind the lens, inside the camera. Since such sensors read only the flash illumination actually coming Through The Lens, "TTL-flash" systems have particular advantages in close-up and multiple-flash photography, and when using filters and very wide-angle and very long telephoto lenses. They also permit a greater choice of lens apertures than do most automatic flash units that use a sensor on the flash.

Most through-the-lens flash sensors actually read light reflected off the film's surface at the instant of exposure. They are, therefore, often referred to as off-the-film or OTF systems.

Dedicated flash units are designed to work with a particular camera model, most—though not all— dedicated flashes also have a sensor on the flash unit itself and can provide automatic flash exposures with any camera when set properly. Similarly, any camera containing an internal flash sensor and electronics designed for compatibility with a dedicated flash can also be used with any non-dedicated automatic flash when set properly.

Important preliminaries

Modern cameras and electronic flash units are capable of producing fine photographs. To achieve success from the beginning, however, it's important to pay careful attention to a few easy-to-understand details concerning 1) energy supply, 2) mating flash and camera, 3) synchronization, and 4) shutter speed. The following chapter is devoted to these mechanical/electrical concerns.

While the basic theory and operation of all electronic flash equipment is quite similar, there are considerable minor differences in physical features among different models. It is important that you carefully read the instruction manuals for both flash and camera. (Misplaced instruction manuals can almost always be replaced by a request to the equipment manufacturer or national distributor. The address is usually obtainable from local camera stores.)

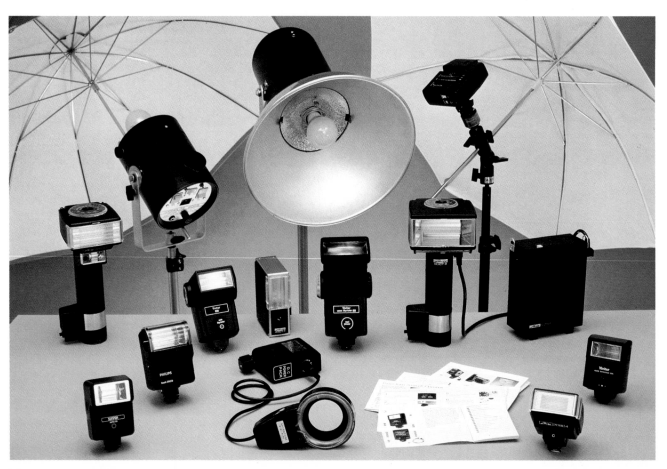

ENERGY

The heart of an electronic flash is its power supply. Batteries are generally relied upon as the primary, convenient portable source of energy. They do require some care and attention and should be the first item to check when the flash is not working properly. An understanding of battery characteristics is important when selecting equipment for your applications. More discussion of battery types and care is on pages 94-95.

Battery contacts can be cleaned by rubbing them with an eraser.

Sliding the flash unit into the hot shoe establishes the electrical connection.

SOME MECHANICAL CONSIDERATIONS

Triggering

The signal from the camera to fire the flash usually comes from an electrical contact in the flash shoe on top of the camera. Because electricity flows through the shoe and into the support foot of the flash, it is called a "hot shoe." Most cameras also have a "sync" (synchronization) outlet into which an electrical cable (called a sync or PC cord) can be plugged. When the flash is used off the camera, or if the camera shoe or flash foot lack electrical contacts, the flash must be triggered from the sync outlet.

Contact Shoes

The number of contact pins on the flash foot and the camera shoe determine flash/camera compatibility. No pins on either means you must trigger the flash through a sync cord.

Hot shoes with *one* pin will fire any flash having one or more contacts. Similarly, a flash with one pin can be triggered by any camera shoe having one or more contacts. However, one pin on either the flash foot or in the camera shoe means dedicated operation is not possible.

Multiple pins indicate internal circuitry for dedicated operation. Check both the flash and camera manuals before assuming that flash and camera will operate as a dedicated pair.

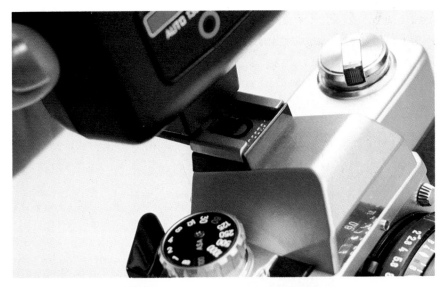

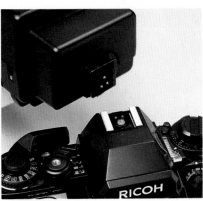

Multiple contacts in the camera shoe and the flash foot indicate provisions for dedicated operation. But an equal number of pins does not ensure compatibility— check instruction manuals.

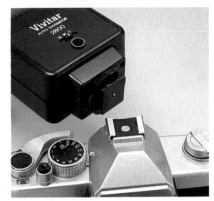

Single contacts will fire any flash, but not in the dedicated mode. Flash exposure automation is still available by using a flash unit with a built-in automatic sensor.

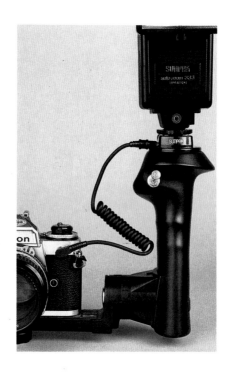

A synch cord may be a 6-inch straight cord or a longer coiled cord, as shown here, that allows the flash to be held off some distance from the camera.

Sync Cord If a hot shoe connection is not provided on camera and flash, or for mounting the flash off camera (see pages 45-57), use a sync cord. These somewhat delicate cords—spares are advised—are not generally interchangeable among different brands of electronic flash. Straight or coiled extension cords are available in various lengths.

Synchronization Electronic flash must be synchronized so that it fires at the instant the camera shutter is fully opened. This is known as X-sync. If the camera has an X/M switch, set it at X. If two outlets exist into which the flash sync cord can be plugged, use the X outlet. Many modern cameras have neither switch nor multiple outlets; they are automatically set for X-sync. (M synchronization is for flashbulbs.) Check your camera instruction manual for flash synchronization information.

For cameras lacking a hot shoe, look for a connecting outlet for the PC cord on the lens barrel or on the front or side of the camera. With a multi-position switch such as at right, set it to "X" for use with electronic flash.

Some cameras offer a choice of synchronization settings-such as "X" for electronic flash and "FP" or "M" for flashbulbs. With a choice of sockets, plug your cord into the "X" socket.

1/1000 second *1/500 second* *1/250 second* *1/125 second* *1/60 second*

Single-lens-reflex 35 mm cameras have a recommended flash synchronization speed—usually 1/60 or 1/125 second. Operation at speeds faster than recommended may give partial images. The sequence above illustrates the shutter set at speeds faster than recommended. The two shutter curtains do not expose the entire film frame to the flash burst. Only at a slower speed (far right) do the curtains fully open when the flash fires to reveal all of the frame.

Shutter Speed Although the duration of the flash—typically 1/1000-second and shorter—determines actual exposure time for a picture, the **camera shutter speed** must be set to provide a fully open shutter when the flash unit fires. Shutters are located either inside the lens (leaf shutter) or directly in front of the film (focal-plane shutter). Focal-plane shutters require particular shutter speed settings for flash photography.

Focal-plane shutters are commonly found in 35 mm cameras that accept interchangeable lenses. Typical electronic flash synchronization speeds would be 1/60, 1/90, or 1/125 second, but consult your camera manual. Shutter speed dials usually indicate the proper setting for flash. Shutter speeds *slower* than the flash synchronization setting are possible, but ambient light may create ghost images around the subject, especially if the camera is handheld and not perfectly stable or if the subject is moving.

Speeds *faster* than recommended produce a picture that shows only a portion of the frame.

Leaf shutters will synchronize with flash at *any* speed. This flexibility makes balancing flash illumination with ambient light relatively easy. Fill-in flash, which requires such a balancing technique, is discussed on page 73. Again, shutter speeds slower than 1/60 second may result in ghost images.

Compatibility Almost any flash unit will work with almost any camera equipped for electronic flash. It's a question of setting the shutter speed, establishing contact and correct synchronization, and adjusting exposure for the film-speed/flash-power/flash-subject distance variables. Some camera/flash units are designed to work together in a so-called dedicated system. Specially designed circuits in both instruments combine to set automatically correct shutter speed, and flash power for correct exposure and to provide viewfinder signals (such as ready-to-flash signal) when the flash is attached to the camera. However, dedicated units will not work in the dedicated mode if not attached to a camera they were designed for.

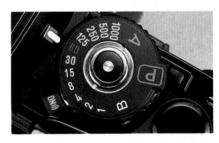

When using a manual or automatic flash unit, you must set the shutter speed dial to the flash sync speed, typically 1/60 or 1/125 second.

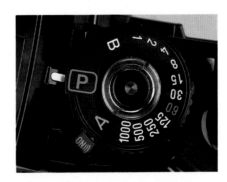

When using a dedicated flash in the dedicated mode, set the exposure mode on the camera to "P" (Some cameras use an "A" setting; see your camera manual). The camera will then automatically set the correct shutter speed for flash photography.

19

Basic operation

The following chapter provides a step-by-step guide to the operation of automatic, dedicated, and manual flash units. Here you'll find a deeper understanding of how to use your flash unit effectively for the pictures you've been waiting to take. This chapter, incidentally, will be far more valuable if you read it with the instruction manuals for your flash and camera close at hand.

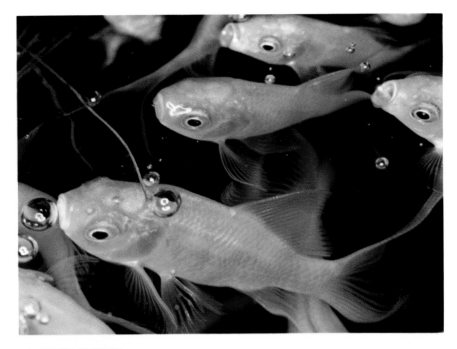

With the latest dedicated flash systems, a sensor located at the film plane in the camera measures light admitted through the lens and reflected off the film. The sensor cuts off the flash when enough light has reached the film. The accuracy of such a system is remarkable and is especially adaptable for such demanding subjects as close-up nature subjects and off-camera flash photography. The fish photographed from a close distance were captured with a dedicated flash system.

THE THREE SYSTEMS

The manner in which the camera and flash controls must be set is determined by which of the operational systems is used. A combination of your equipment and working style, along with the photographic situation at hand will determine whether you use *manual, automatic,* or *dedicated* operation.

Before discussing the proper settings, we will summarize below the attributes of each system and then provide information that will help you determine what type of camera and flash you have, or may wish to buy.

Automatic Flash

These units provide automatic exposure control for a fixed number—typically two to four—of camera lens apertures. Any automatic flash (with a sensor on the flash) may be used on any camera, and most such flash equipment can also be set to operate manually.

To provide correct exposure, the automatic sensor must face the subject and be close to the camera. If you wish to use bounce flash, chose a unit that has a swiveling head so the sensor will point forward regardless of the direction of the light output. Alternatively, some flash equipment permits the sensor, via an electrical cord, to remain on the camera while the flash is positioned off camera in any orientation desired.

Dedicated Flash (Sensor on the flash)

If the camera does not have an internal flash sensor, a dedicated flash will provide the same features as mentioned above for standard automatic units, along with conveniences such as automatic setting of the correct shutter speed (and automatic aperture setting on some "program" cameras), and flash-ready and sufficient-light indicators inside the camera viewfinder.

Dedicated flashes made by camera manufacturers will not work in the dedicated mode on other brands of cameras, and sometimes not even on all models of a particular brand. In most cases this shortcoming can be overcome by using an independent brand flash that offers a variety of interchangeable dedicated modules.

Dedicated Flash (Sensor in camera)

When the flash sensor is located inside the camera (TTL flash), automatic features include all those of dedicated flash units having sensors on the flash, plus the following advantages: 1) a greater choice of lens apertures for a given distance range, which offers more control over depth of field; 2) because very small and very large apertures can be used, both the near and far automatic flash photography distance limits are extended; 3) a flash sensor inside the camera is also extremely helpful in close-up photography and when using filters; and 4) with the proper interconnecting cords, a number of dedicated flash units may be simultaneously controlled by the TTL sensor.

Manual

Manual operation requires a different aperture for each flash-to-subject distance, which makes general picture taking less convenient. Manual operation also uses the most battery power because each burst puts out that flash unit's maximum possible light, although some units do have variable intensity controls. (Most automatic and dedicated flashes conserve power by only generating as much light as a particular aperture and distance require.) Manual operation must be used with all studio and many portable, professional-size flash units which have no automatic exposure control. Even automatic flashes are used manually for multiple-flash photography, or where very exact exposure and lighting control are required, and where a flash meter and/or instant films are used to determine correct lens aperture. Manual operation is also appropriate for fill-in flash.

MATCHING CAMERA AND FLASH
What Type of Camera?

How you set your flash depends on the type of camera it will be used with. Most flash equipment can be used with a variety of cameras, but different settings may be required.

Cameras that have leaf shutters inside the lens include most 35 mm cameras with non-interchangeable lenses, many medium-format cameras, and most large-format cameras. These may be used with any manual flash, or with any automatic flash that has a sensor on the flash. In general, dedicated systems are not available for leaf-shutter cameras. Leaf shutters will synchronize with electronic flash at any shutter speed. 1/125 or 1/250 of a second is usually appropriate, but you can use other speeds (see page 19).

Interchangeable-lens 35 mm cameras have focal plane shutters that require a particular flash sync shutter speed. You must set the camera to that speed when using manual flash, or automatic flash with a sensor on the flash. When dedicated flash equipment is used with the camera for which it is intended, the camera usually must be set to "Automatic" or "Program" (consult the instruction booklet); this will automatically set the proper flash sync shutter speed when the flash is turned on. If you have a camera with "Program" mode, and use it with its dedicated flash, both the shutter speed and the lens aperture will be automatically set. However, by using apertures other than the one selected by the programmed automation, a greater range of flash photography distances (and techniques such as bounce flash) is possible.

Switching the camera from "Program" to "Automatic" allows the user to set the aperture while keeping all other dedicated features. The instruction booklet will indicate the allowable flash photography distance range for each aperture.

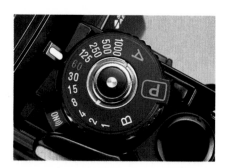

When the camera is set on "Automatic" (A) for use with a dedicated flash, you select the aperture based on the desired depth of field and distance range.

Different models of cameras and flash units vary in the exact manner in which they must be set, and in the distance ranges allowed for flash pictures. Read your instruction manual!

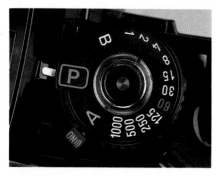

Cameras having "Program" (P) automation set the lens aperture automatically when used with a dedicated flash. That aperture is appropriate for direct flash photography at moderate distances.

Set the shutter speed dial to the correct flash sync speed when using non-dedicated flash.

MATCHING CAMERA AND FLASH
What Type of Flash?

Automatic Flash (Sensor on Flash)
A light sensor on the front of a flash unit indicates it is capable of automatic exposure control with almost any camera. Automatic exposure is usually permitted at two or more lens apertures, the recommended apertures generally indicated by corresponding colored mode settings.

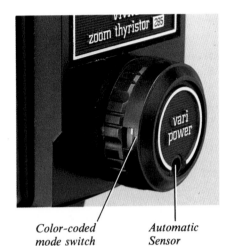

Color-coded mode switch *Automatic Sensor*

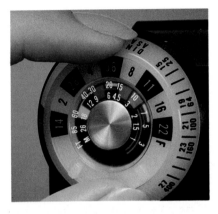

Calculator dial with color-coded modes for distance/aperture selection

DEDICATED FLASH

You have a dedicated flash if its contact shoe has more than one pin. However, check the instruction booklet to make certain it is compatible for dedicated operation with your particular camera model. If the flash unit has no sensor of its own, it can only be used with the specified camera(s). When a dedicated flash does have its own sensor, switch the flash to "TTL" for dedicated operation as shown at right.

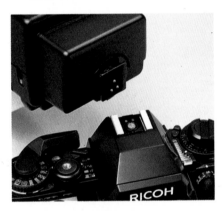

Camera shoe and flash foot with matching multiple pins

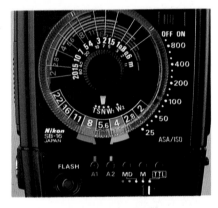

Set for TTL operation

MANUAL FLASH

Almost all flash units can be used manually by switching them to "M". Some flash equipment has no provision for automatic exposure and can only be used manually. Most camera-mounted flash units have a scale (right) that shows the lens aperture you must set for a given flash-to-subject distance. For equipment lacking such a scale, the lens aperture will have to be chosen by using the guide number found in the instruction booklet.

Calculator scale for manual operation

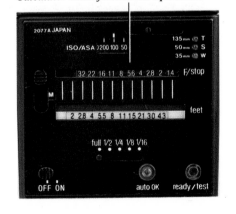

The guide number at various film speeds and zoom head settings is shown in the following table:

Guide numbers in the manual mode Unit: m (ft)

Zoom head setting	ASA/ISO film speed					
	800	400	200	100	50	25
T	119 (390)	84 (276)	59 (194)	42 (138)	30 (98)	21 (69)
S	107 (351)	76 (250)	54 (177)	38 (125)	27 (89)	19 (62)
N	90 (295)	64 (210)	45 (148)	32 (105)	22 (72)	16 (52)
W₁	76 (250)	54 (177)	38 (125)	27 (89)	19 (62)	13 (43)
W₂*	54 (177)	38 (125)	27 (89)	19 (62)	13 (43)	9.5 (31)

* W₂ is used when the wide-flash adapter is attached to the flash unit with the zoom head set at W₁.

TAKING THE PICTURE WITH MANUAL FLASH

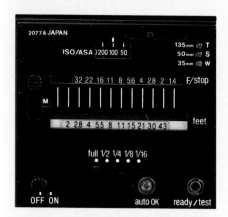

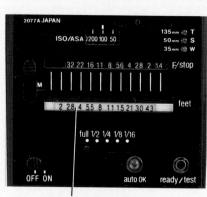

Calculator Scale

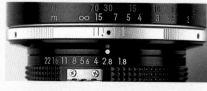

1. Set the film ISO speed on the flash calculator scale. If the flash has no scale, check the flash instruction booklet for the *guide number* to use with a film of that ISO speed.

2. Insert the flash foot into the camera hot shoe. Alternatively, use a sync cord (page 18) between camera and flash when the flash is mounted off the camera, when using large studio flash equipment, or when the camera has a "cold" shoe (no electrical contacts).

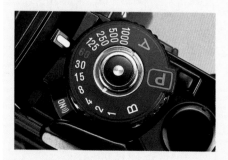

3. Adjust the camera shutter speed dial to the proper flash sync shutter speed (see pages 18-19). This speed is typically 1/60 or 1/125 second for SLR cameras.

4. Determine the distance to the subject by focusing on it and then referring to the distance scale on the lens.

5. Set the flash to manual. The calculator scale indicates the appropriate apertures to use for various flash-to-subject distances. Disregard the colored markings used for automatic operation. This example, for an ISO 100 film, shows that *f*/2.8 is required at about 30 feet.

 If there is no calculator scale, make your own aperture-vs-distance table by doing the following:

 Using the guide number (GN) found in the flash instructions, divide the GN by the flash-to-subject distance to get the lens aperture. (See p. 40 for more information.) Here, a table was made using the manufacturer's suggested guide number (80) for an ISO 100 film.

GN 80 for ISO 100 Film

Dist.	Full
5 ft	*f*/16
10 ft	*f*/8
15 ft	*f*/5.6
20 ft	*f*/4
30 ft	*f*/2.8

6. If the flash has settings for ½, ¼, etc. power, generally use full power. The fractional settings are most often used for close-up photography and fill-in flash, and with fast films.

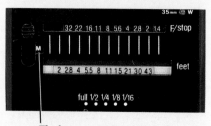

Flash set to "M" (Manual)

7. Turn the lens aperture to the f-stop indicated by the calculator scale, or by your guide number table. For the picture below, taken from 30 ft with an 85 mm lens, the required aperture was *f*/2.8.

8. Switch on the flash and wait for the ready-light. Some cameras must also be set to "ON" or to "Manual". Many cameras will not fire the flash until the frame counter reads at least "1."

9. Take the picture.

TAKING THE PICTURE WITH
AUTOMATIC FLASH (Sensor on Flash)

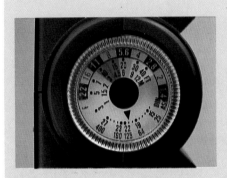

1. Set the film ISO speed on the flash calculator scale. The ISO speed is written on the film carton and on the film magazine. A setting of ISO 100 was used on this flash.

2. Mount the flash by inserting the flash foot into the camera hot shoe. If the camera has a "cold" shoe (no electrical contacts) or if the flash is mounted on a light stand or side bracket, plug a sync cord (page 18) into the camera sync outlet.

3. Set the shutter speed dial to the proper flash sync shutter speed, typically 1/60 or 1/125 second. (see pages 18-19). **Do not set the camera to automatic.**

4. Determine the distance to the subject by focusing on it and then referring to the lens distance scale.

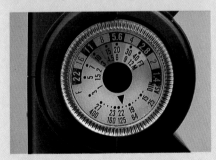

5. From the flash calculator scale, choose one of the allowed apertures, which are usually indicated by a color code. In this example, with the

ISO at 100, only $f/2.8$ (yellow), $f/4$ (red), $f/8$ (blue), and $f/11$ (purple) may be used. (Since there is no colored mark opposite $f/5.6$ on this flash, $f/5.6$ is an unallowed aperture at ISO 100.) The smaller apertures (higher f-numbers) give more depth of field for a given distance, but also use more battery power.

You will get proper direct flash, automatic exposure at any of the allowed apertures, but only if your flash-to-subject distance is within the specified range shown on the flash for each allowed aperture. Consult your flash instructions for the proper way to read that scale. This is very important since photographing outside the stipulated distance range is the greatest cause of incorrectly exposed flash pictures.

Bounce-flash photography produces pleasantly soft light, and it can be done quite successfully with an automatic flash. However, for most situations, you must use the largest allowed lens aperture, which in this example is $f/2.8$. (If you have a large, professional flash, and/or the subject and bounce surface are close to the flash, you may be able to use smaller apertures.) The large apertures are necessary because the flash-to-subject distance is long, and because the light scatters in all directions when it strikes the bounce surface. (See pages 48-53.)

6. Based on the lens aperture you have chosen from the calculator scale, switch the flash to the corresponding mode. In this example, our choice of $f/11$ is opposite the purple mark. Therefore we set the mode switch to purple.

7. Set the lens. Turn the lens aperture to the f-stop that corresponds to the mode selected on the flash. In this case we have chosen $f/11$, the smallest aperture allowed (for an ISO 100 film) by the flash. A small aperture was chosen to provide maximum possible depth of field in this scene that has considerable front-to-back depth, and was taken from a fairly close distance. (Depth of field decreases as you get closer to your subject.)

8. Switch on the flash and wait for the ready light. Some cameras must also be set to "ON." Many cameras will not fire the flash until the frame counter reads at least "1" or higher.

9. Take the picture.

10. Some flash units have an LED (confidence light) that lights immediately after the flash is fired, but only if the subject has received sufficient exposure. (Unfortunately, they also light when there is too much exposure—bad for slides, but not as bad for negative films.) If exposure is inadequate, move closer or choose a mode with a larger allowed aperture.

Confidence light

TAKING THE PICTURE WITH DEDICATED FLASH

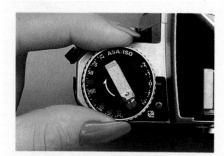

1. Set the film's ISO speed on the camera, and on the flash if it has a film-speed control. (Some cameras automatically set the film speed.)

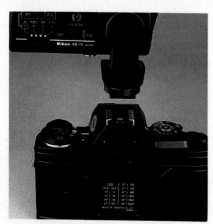

2. Mount the flash. Insert the flash foot into the camera hot shoe. If the flash is used off the camera, on a light stand or side bracket, obtain an appropriate multi-pin extension cord designed for that dedicated system.

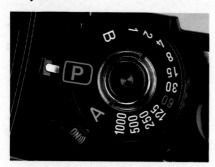

3. Set the mode switch on the camera to either "A" (automatic) or "P" (program)—a few cameras offer both settings. "A" allows you to set the aperture; "P" makes the camera set the aperture. At either setting, the camera will now set the correct shutter sync speed when the flash is turned on.

4. With dedicated flash systems that do not have a sensor in the camera (non-TTL flash), select an aperture as discussed in steps 4-6, page 25, for conventional automatic flash.

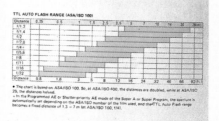

5. When using a dedicated system in "P" (Program) mode, the camera will automatically select an aperture. However, *check the instruction book to determine the allowed distance range for flash photography.* If you are using the "P" (Program) mode on the camera, set the lens to the "A" or (on some cameras) "P" setting.

6. With TTL dedicated flash, and the *camera set to "A" (Automatic),* any lens aperture may be used, *but only if* your flash-to-subject distances fall within the specified distance range designated for each aperture. Those near and far distance range limits can be found either on the distance range scale of your flash, or in the flash instructions as shown in the photo above. Staying within the range designated for each lens aperture is very important since photography outside the stipulated distance range is the greatest cause of incorrectly exposed flash pictures.

Also note that small lens apertures (high f-numbers) give more depth of field, but also use more battery power, and decrease the limits at both the near and far end of the distance range.

Bounce-flash photography produces pleasantly soft light, and it can be done quite successfully with a dedicated system as long as the camera is set on Automatic (*not* Program). However, *you must use a large lens aperture* (small f-number) because the flash-to-subject distance is long and because the light scatters in all directions when it strikes the bounce surface. (See pages 48-53).

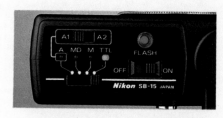

7. Switch the flash to TTL (or OTF). If a dedicated flash does not use a sensor inside the camera, set the flash mode as discussed on page 25, steps 4, 5, and 6, for conventional automatic flash.

8. Switch on the flash and wait for the ready light which usually appears both on the flash and in the viewfinder. Some cameras must also be set to "ON." Many cameras will not display the viewfinder ready light, nor will they fire the flash, until the frame counter is at "1" or higher.

9. Take the picture.

10. Many dedicated systems indicate adequate flash exposure by the presence of a viewfinder signal immediately after the flash is fired. (Unfortunately, they also light when there is too much exposure—bad for slides, but not as bad for negative films). If exposure is inadequate, move closer or use a larger aperture.

Confidence light

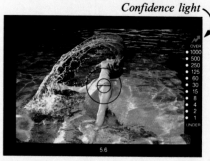

The confidence light (green arrow) glows when the exposure is correct.

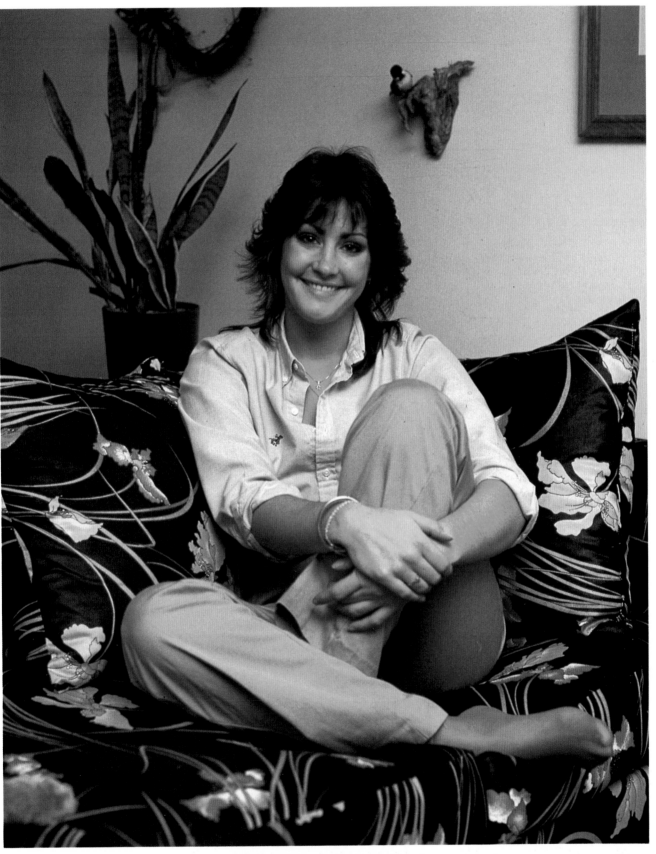

Bounce flash was used to create the soft lighting in this photo. See pages 48-53 to learn about bounce flash.

DISTANCE CONSIDERATIONS

A common cause of improperly exposed automatic or dedicated flash pictures is working outside the flash-to-subject range permitted for a particular lens aperture. Here's how to prevent that.

First, know your distance accurately; don't guess. For direct flash, use the flash-to-subject distance. When you focus the camera carefully, the distance figure is indicated right on the lens barrel. Second, for best results don't work too close to the extreme ends of the range.

For example, let's say your subject is 10 ft away. Your automatic or dedicated flash may have a range of 3 to 10 ft at $f/8$ (ISO 100). At $f/4$ the same flash has a range of 3 to 20 ft. Since 10 ft is at the very end of the range for $f/8$, but comfortably within the range for $f/4$, the $f/4$ aperture is more likely to give full exposure.

The calculator scale is your key to properly exposed flash pictures. These scales tend to have, at first glance, a bewildering array of numbers: distances in feet and meters, indicators for automatic and manual mode, a variety of allowed apertures, and a wide range of ISO film speeds. But with a little study, you will see that the scales are logically laid out, and that when you know where to look, the information is accessible.

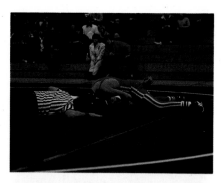

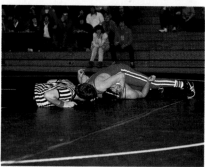

The top photo, taken with an automatic flash at 3 ft, is overexposed because the photographer incorrectly chose an aperture that had an allowed distance range of 5 to 20 ft. By using a smaller aperture, one that permitted automatic, direct flash between 3 and 11 ft, a properly exposed photo was achieved.

*In the top photo, the photographer used too small an aperture for the distance to the subject. By referring to the calculator scale, he found the aperture appropriate for the distance and made a correct exposure of the wrestlers, **bottom photo.***

To determine the flash-to-subject distance for direct flash, just focus the camera accurately and read the distance from the scale on the lens. In this example it's 10 ft. With manual flash this distance precisely dictates the correct aperture. With automatic or dedicated flash it is not necessary to know the exact distance for each picture as long as distances fall within the distance range allowed for the aperture you select. This calculator scale shows (for ISO/ASA 100) that the subject can be from 3 to 20 ft away with the aperture set at $f/4$. All photos taken within this distance range will be correctly exposed. Just focus and shoot! Don't change the aperture; don't look at the calculator scale!

FLASH WITH OTHER LENSES

The beam spread of a standard flash is designed to cover the area encompassed by a camera's normal lens. Some flash equipment will cover a slightly wide-angle optic, such as a 35 mm lens on a 35 mm camera, or a 60 mm lens on a $2^1/_4$ x $2^1/_4$ format camera, but do check your flash instruction manual before attempting wide-angle flash photography.

The photos at right illustrate the covering power of an electronic flash unit with a zoom flash head. At top you see the normal lens setting of the zoom head. The center illustration shows the wider and shorter pattern thrown by the wide-angle setting. The bottom view shows the long, narrow coverage of the telephoto setting.

Flash with Wide-Angle Lenses

An excellent flash technique for illuminating the broad area seen by a wide-angle lens is bounce flash, which is discussed on pages 48-55. Here, however, we concentrate on methods which spread the direct flash beam. These techniques are effective for wide-angle lenses with focal lengths as short as 24 mm when used on a 35 mm camera, or 40 mm for 2$\frac{1}{4}$ x 2$\frac{1}{4}$ cameras.

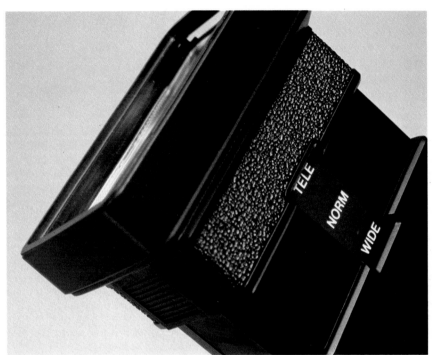

1. Accessory frosted plastic diffusers (above) which attach to the front of a flash are available in various densities, depending on beam spread required. No exposure compensation is necessary when using automatic flash. However, both the minimum and maximum points of an automatic range decrease by 25 to 50%. Consult the instructions that come with the diffuser. In manual mode, the guide number decreases. Here, too, check the instructions.*

2. Similar in function to the diffuser at left, transparent plastic Fresnel lenses, offered as accessories by the flash manufacturer, also attach to the flash head. Tiny grooves cut in the plastic disperse the light beam but with less loss of intensity than occurs with diffusers. Additionally, Fresnel lenses come in specific designs to match the field of view of specific camera lenses. They require exposure considerations similar to those noted for diffusers.*

3. Zoom flash units (above) are constructed with a Fresnel lens mated to a housing which slides in and out over the flash head. This configuration is able to change the beam spread, usually from moderately wide-angle, through normal, to moderately telephoto. Since they are an integral part of the equipment, zoom heads are more convenient than individual Fresnel lenses, though they often do not cover as extreme a range as the latter. Again, maximum and minimum ranges in the automatic mode decrease at the wide-angle setting, as does the guide number for manual operation.*

*The sensor of an automatic flash, except those dedicated systems where the sensor is mounted behind the lens, may not see the scene the same as the lens and flash. Some compensation may be necessary for extreme or unusual situations.

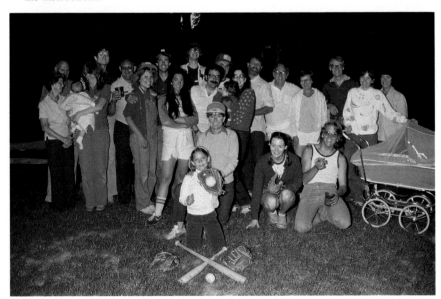

To provide even illumination for this large, widespread group of merrymakers the photographer used a wide-angle Fresnel lens fitted over the flash head.

Flash with Wide-Angle Lenses: Distance Considerations

When wide-angle attachments are used on a flash, the light is spread over a much broader area. Since more light is dissipated to the sides, there is less available to reach distant subjects. Similarly, there is less intensity on near subjects.

Therefore, with any type of automatic flash, there is a *decrease* in both the near and far limits of the distance range covered at any allowed lens aperture.

In manual mode the guide number decreases, so you must use a larger aperture (smaller *f*-number) than you would for the same distance without a wide-angle attachment.

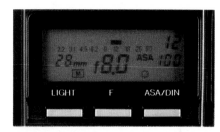

DEDICATED FLASH

Consult the flash equipment instruction manual to find the allowed distance range which corresponds to each lens aperture. Alternatively, on the calculator scale of some flash units you will find a distance range indicator for use with the wide-angle attachment.

In this example, a flash having a zoom head was used in its wide-angle position to cover the area seen by a 28 mm lens on a 35 mm camera. The flash's calculator scale shows that at *f*/8, ISO/"ASA" 100, the maximum distance is 12 feet. (The same system reaches to 17 feet when the zoom head is adjusted to match a 50 mm normal focal-length lens.) When the near distance limit is not provided on the calculator scale that information can usually be found in the instruction booklet.

Sample Table GN 80 for 28 mm Lens with ISO 100 Film	
Distance	**f-stop**
5 ft	*f*/16
10 ft	*f*/8
15 ft	*f*/5.6
20 ft	*f*/4

MANUAL FLASH

The calculator scale on some flash units shows the distance-vs.-aperture settings to use with that flash's wide-angle attachment. More often, though, the manufacturer provides the guide numbers to use with the wide-angle attachment, and for films having various ISO values.

Use that guide number to make a reference scale for your flash. Divide the guide number by typical flash-to-subject distances (e.g. 3,5,8,10 . . . feet). The results of each division (the quotient) is the aperture to use at that distance. Shown here is just such a homemade scale: With the 28 mm flash attachment and an ISO 100 film, the flash manufacturer recommended a guide number of 80. Without the wide-angle attachment, the guide number is 110.

AUTOMATIC FLASH (Sensor on Flash)

Consult the flash equipment instruction manual to find the distance range for each allowed aperture. Alternatively, on the calculator scale of many units you will find a distance range indicator for use with the wide angle attachment. In this example with ISO 100 film, for an *f*/2 aperture (red mode), the maximum distance is 33 feet when the wide-angle attachment is used, 60 feet when the attachment is removed.

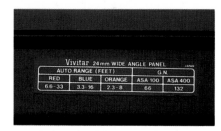

Failure to use a wide-angle attachment on the flash when photographing with a wide-angle lens will cause the perimeter of the picture to be dark. However, the wide-angle flash attachment is often intentionally omitted to create a "spotlight" effect. Here the camera lens was a 28 mm wide-angle, the flash a standard unit used without a wide-angle attachment.

Flash with Telephoto Lenses

With flash heads designed to cover a field seen by normal focal length camera lenses, there is more than enough light coverage of the scene for telephoto lenses. No changes in exposure procedures are required for either automatic or manual mode.

But why waste valuable light on parts of the scene not even noticed by the camera lens? By concentrating the flash output into a narrow beam that duplicates the angle of view of a telephoto lens, this wasted illumination can help to increase the distance range of the flash and/or decrease the size of the aperture for greater depth of field and/or conserve battery energy.

Few birds would permit photography at this close range. The photographer used a flash with a zoom to match the light pattern to the coverage of the telephoto lens.

Note: Just as a spotlight effect is created when wide-angle camera lenses are used with normal flash heads, a similar effect may be realized by using a normal camera lens and a flash fitted with a telephoto attachment.

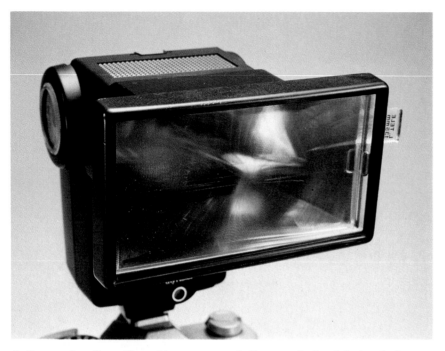

1. Inexpensive clip-on Fresnel lenses (above) are available to concentrate the flash beam. They are identical in style to those mentioned before for wide-angle beam spread. Specific Fresnel lenses are made to match the angle of view of most telephoto lenses up to about 200 mm for a 35 mm camera (or equivalent for other camera formats). Note that you can always use a camera lens that has a focal length equal to or longer than the focal length meant to be covered by the Fresnel lens.

 When telephoto Fresnel lenses are employed with automatic flash units, both near and far automatic-range limits increase considerably. It then becomes very easy to overexpose subjects by inadvertently working too close. In manual mode, guide numbers also increase considerably—a definite advantage for sports or distant nature photography. Consult the instructions for the Fresnel lens to find corrected values for automatic ranges and for guide numbers.

2. The same zoom flash unit mentioned earlier for wide-angle lenses also have settings which cause the beam angle to coincide with that of moderate telephoto lenses. Automatic ranges and guide numbers are increased in a similar manner as with the Fresnel lenses noted directly above.

3. Some professional flash units have removable reflectors which may be interchanged behind the flash tube. If available, a deep, polished parabolic bowl provides the required concentrated beam of light for telephotography.

You've already guessed that this picture was made from terra firma rather than the chilly water of the pool. With a telephoto attachment for the flash unit, the photographer was able to supply enough light to catch this swimmer close-up with a telephoto lens.

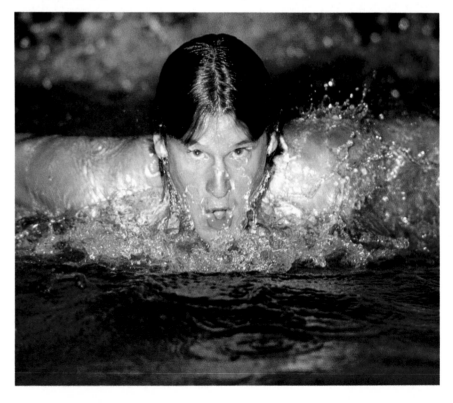

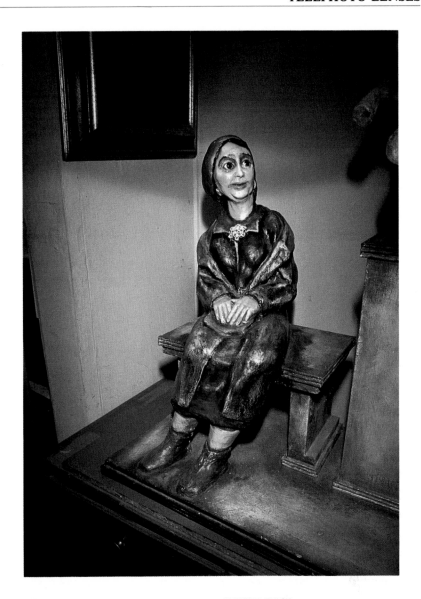

The telephoto flash attachment is generally used for long-distance photography with telephoto lenses. However, the narrow beam created by the telephoto flash can be used to create a spotlight effect when it is used with a normal or wide-angle camera lens. Here the flash was fitted with a 135 mm Fresnel lens, while the camera optic was the normal 50 mm focal length.

Flash With Telephoto Lenses:
Distance Considerations

When telephoto attachments are used on a flash, the light is funneled into a much narrower beam. The light is therefore more intense at a given distance, allowing you to photograph at a greater distance than possible without the telephoto attachment. However, be careful not to overexpose nearby subjects.

With any type of automatic flash, there is an increase in both the near and far limits of the distance range covered at any allowed lens aperture.

In manual mode, the guide number increases, so you must use a smaller lens aperture (larger f-number) than you would for the same distance without a telephoto attachment.

AUTOMATIC FLASH (Sensor on Flash)

Consult the flash equipment instruction manual to find the distance range for each allowed aperture. Alternatively, on the calculator scale of many units you will find a distance range indicator for use with the telephoto attachment. In this example with a 135 mm lens and ISO 100 film, for an $f/2$ aperture (red mode), the maximum distance is 93 feet when the telephoto attachment is used, 60 feet when the attachment is removed.

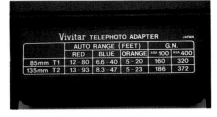

DEDICATED FLASH

Consult the flash equipment instruction manual to find the allowed distance range which corresponds to each lens aperture. Alternatively, on the calculator scale of some flash units you will find a distance range indicator for use with the telephoto attachment.

In this example, a flash having a zoom head was used in its telephoto position to cover the area seen by a 105 mm lens on a 35 mm camera. The flash calculator scale shows that at $f/8$, ISO/"ASA" 100, the maximum distance is 19 feet. When the near distance limit is not provided on the calculator scale, that information can usually be found in the instruction booklet.

MANUAL FLASH

The calculator scale on some flash units shows the distance-vs-aperture settings to use with that flash's telephoto attachment. More often, the manufacturer provides the *guide numbers* for various telephoto attachments and film speeds.

To make a reference scale for your flash, divide the guide number by typical flash-to-subject distances (e.g., 10,20,30,40 . . . feet). The result quotient of each division is the aperture to use at that distance. Shown here is just such a homemade scale based on a guide number of 160.

Sample Table
GN 160 for 105 mm Lens
with ISO 100 Film

Distance	f-stop
10 ft	$f/16$
20 ft	$f/8$
30 ft	$f/5.6$
40 ft	$f/4$

Testing your flash

The information up to this point will help you get properly exposed flash pictures if your flash unit meets its specifications. However, that's not always the case. Some flash units may put out less (or even more) light than specified, resulting in exposures that may be slightly off. This chapter helps you calibrate your flash system for precise exposure and covers the atypical situations that can result in poor exposure.

Automatic and dedicated flash units work best with scenes of average reflectance. The all-white scene shown below would fool an automatic or dedicated flash into underexposing the photograph. For a very light or dark scene, manual flash works better, although you can adjust automatic and dedicated units to provide correct exposure. (See page 42.)

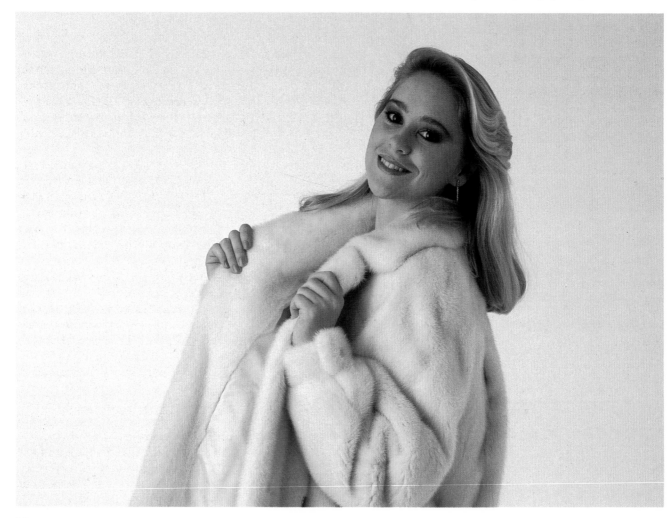

READY LIGHT

All electronic flash units have a ready light (usually red or orange) that glows to indicate when the capacitor has charged sufficiently to fire again and produce a satisfactory exposure. It will be only satisfactory because the ready light on most consumer flash units glows when the capacitor is 70 to 85% charged. Full, 100% charge takes about 50% longer. On some equipment the ready light will eventually blink to signal 100% charge.

In the automatic mode, firing the flash when it is only 75% charged produces properly exposed film, unless, due to distance and/or lens aperture, maximum power is called for. In that case, photographs will be ¹/₂ stop or more underexposed.

Manual flash exposure, however, relies on 100% power for every shot. Therefore, in the manual mode, failure to wait for 100% charge results in consistently underexposed film.

Most professional flash units have ready lights which do indicate 100% charge as soon as they glow. With all equipment, though, consult the instruction manual.

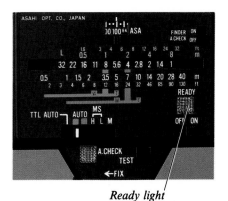

Ready light

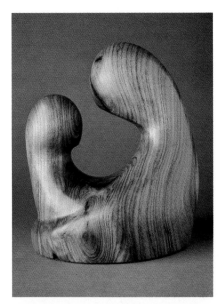

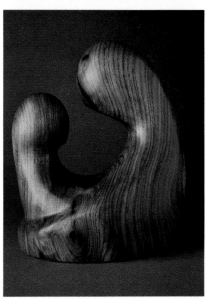

*Most electronic flash units have a small orange light, **left,** that glows when the unit has recycled and is ready for the next shot. Usually this light indicates partial recycling—perhaps a 75% charge. It's wise to wait a few extra seconds for full power. Some units have a ready light that blinks when the capacitor has stored full power.*

The bottom picture of the sculpture demonstrates the underexposed results from incomplete recycling with a manual flash unit. The comparison top photo shows correct exposure at full power. If discharged prematurely, an automatic flash unit may give enough light if the subject is closer than the maximum distance range for the mode set.

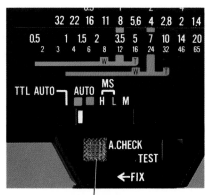

Confidence light

Use the confidence light to check for sufficient illumination in marginal situations. To save film, fire the flash with its test button while observing the confidence light. (With TTL flash, the camera must be fired).

CONFIDENCE LIGHT

Some automatic flash units display an indicator light immediately after the flash is fired to signal that the subject has received adequate illumination. Most dedicated systems have these indicators—called *confidence or sufficient light signals*—inside the camera viewfinder.

A confidence light is particularly useful in marginal situations (such as bounce flash, the far end of the allowed distance range, or with unusually dark subjects) where you may need more illumination than the flash can provide.

When the confidence light fails to come on, move closer, or, with an automatic (sensor-on-flash) system, switch to a mode that permits a larger aperture. With a dedicated TTL system, open the lens aperture.

Unfortunately confidence indicators will also light when there is too much illumination (usually when you are too close and/or are using too large an aperture.) This will usually not be a problem with negative films which have tolerance to overexposure, but it can produce washed out results with slide films.

THE IMPORTANCE OF TESTS

We strongly advise that you test and operate new flash equipment with film in the camera and in typical shooting situations before you rely upon it for important work. During such testing you can become more familiar and dexterous with the mechanical procedures.

An equally important reason for the serious photographer to test new equipment is to make sure that film is receiving what *you* consider proper exposure. You may have strong feelings about how much exposure is needed for the images you shoot. Without flash, you meter light on the scene, make any necessary compensation, adjust your camera, and shoot. Testing the output of your flash gives you the same confidence in your flash exposure as familiarity with your camera meter gives you for natural-light exposure.

Automatic sensors are designed to cut off the flash when film has been exposed according to the flash manufacturer's standards. *Does the manufacturer test on negative or slide film? If slide film, on what projector or light box are transparencies viewed, and at what magnification? If negative film, do their ideas of shadow detail coincide with yours?*

Similarly, the flash manufacturer's published guide numbers, which are also used to provide the suggested lens aperture on the exposure calculation of the flash unit, are just that — guides and suggestions. They are based on so-called average conditions: small-to-medium-size rooms with white ceilings and light-colored walls, and medium-tone subjects. Such situations do exist certainly but not always.

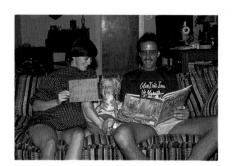

Exposure recommended by flash

Exposure we liked

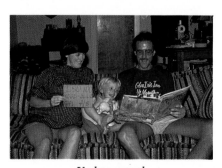

Underexposed

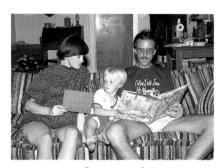

Overexposed

For our tastes, the aperture f/6.7 (between f/5.6 and f/8) recommended by the flash dial resulted in slight underexposure. We preferred the picture taken with the lens aperture opened up to f/5.6.

EXPOSURE TESTS WITH AUTOMATIC FLASH
(Sensor on Flash)

1. For testing, slide film, such as **KODAK EKTACHROME 100**, is strongly recommended since it is easier to evaluate and less expensive than negative film.

2. Make certain that all camera and flash controls (shutter speed, lens aperture, flash sensor, film ISO speed) are properly set. The test scene should contain primarily medium-tone subjects, or a good mix of light and dark tones.

3. Start by exposing according to the manufacturer's recommendations. Instead of taking notes, put a small card in the scene (off to the side) indicating:
 a. film ISO speed
 b. lens aperture
 c. sensor setting
 d. flash-to-subject distance; for initial tests, this distance should fall about in the middle of the allowed range for each automatic mode. Later you may want to test automatic exposure accuracy at the end points of the range.

4. Now, without changing anything but the lens aperture and the information on the card, take the identical picture with the lens open ¹/₂ stop larger.

5. Continue this bracketed series of exposures for 1 full stop larger aperture, 1¹/₂ stops larger, and finally ¹/₂ stop smaller. Seldom is it necessary to go far in the underexposed direction.

6. Repeat steps *3,4,5* above, for other scenes and distances.

7. Process the film in your normal manner, or send it to your usual processing lab. Then, using your standard viewing conditions, select the exposure for each scene that you deem correct.

8. Our illustrated test results show that the lens had to be opened ¹/₂ stop more than the flash manufacturer's recommendation.

EXPOSURE TESTS WITH DEDICATED FLASH

For dedicated flash units whose sensor is on the flash (not in the camera), use the procedure for automatic flash on page 38. For dedicated units with the sensor in the camera (TTL units), start by following steps 1-3 on page 38, and then continue with these steps:

4. Without changing anything but the camera exposure compensation dial, take the identical picture with the exposure compensation set at +$\frac{1}{2}$ stop (or at +$\frac{1}{3}$ stop if your compensation dial is marked in $\frac{1}{3}$ increments). Make sure to give your subject a new card for each exposure.

5. Continue this bracketed series of exposures for +1, +1-$\frac{1}{2}$ and -$\frac{1}{2}$ stops. (Seldom is it necessary to go far in the underexposure direction.

6. Repeat steps 3,4,5 above for other scenes, other distances and other apertures.

7. Process the film in your normal manner, or send it to your usual processing lab. Then, using your standard viewing conditions, select the exposure for each scene that you deem correct.

8. If test results indicate that proper exposure consistently requires a particular setting of the exposure compensation dial, then use that setting for future flash photography. If you find compensation is only required for distances at the ends of a range allowed for a particular aperture, you can usually avoid the need for compensation by changing the aperture so the distance falls more nearly in the middle of the allowed range.

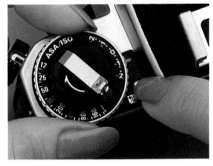

The camera exposure compensation control can be set to correct for consistently over- or underexposed flash photographs taken with TTL flash systems.

These test photographs were exposed with a TTL dedicated flash system at the same distance. For our picky tastes, the top picture, using the manufacturer's recommended setting, is slightly underexposed. A preferred exposure was achieved by setting the camera's exposure compensation dial to +$\frac{1}{3}$ stop.

Exposure set by dedicated system

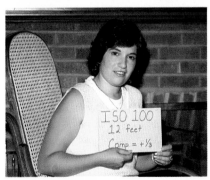

Exposure we liked

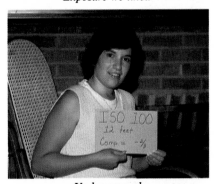

Underexposed

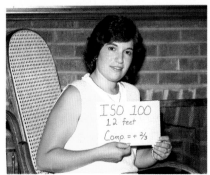

Overexposed

GUIDE NUMBER CHART

Film Speed	Distance in Feet						
	3	5	7	10	15	20	25
ISO 100	~f/22	f/16	f/11	f/8	f/5.6	f/4	f/3.5
ISO 200	—	f/22	f/16	f/11	f/8	f/5.6	f/4.8
ISO 400	—	—	f/22	f/16	f/11	f/8	f/6.7

If your flash lacks a calculator scale you can make your own guide number chart. This chart was made based on a guide number of 80 for ISO 100 film. The guide number (for ISO 100 film) was divided by various distances to obtain the correct aperture for each flash-to-subject distance. The apertures for ISO's 200 and 400 came from using the formula in step 11 below.

For an ISO 100 film, the calculator scale indicated an aperture of f/8. But at f/8, the scene was slightly underexposed.

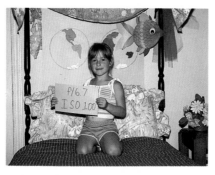

This is the test exposure chosen as correct from the bracketed series with an ISO 100 film. Because the aperture is f/6.7 and the distance is 10 ft., the guide number is 6.7 X 10 = 67.

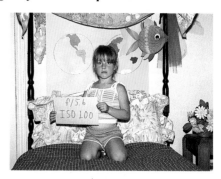

Overexposure—1 stop more than recommended by flash.

EXPOSURE TESTS WITH MANUAL FLASH

1. For testing, slide film is strongly recommended since it is easier to evaluate, less expensive, and less forgiving than negative films.

2. Select a scene that contains primarily medium-tone subjects, or a good mix of light and dark tones. Make certain the camera and the flash are set for "Manual" and that the shutter speed is correct.

3. Place the flash exactly 10 ft from the subject.

4. As a starting point, expose according to the manufacturer's recommendations; use the aperture suggested on the calculator scale for 10 ft. If no scale exists, determine the aperture by dividing the suggested guide number by 10 (for 10 ft).

5. Instead of taking notes, put a card in the scene indicating:
 a. film speed
 b. lens aperture
 c. flash-to-subject distance (10 ft)
 d. any other pertinent information, e.g. power setting ($\frac{1}{2}$, $\frac{1}{4}$, etc.), or type of reflector (wide-angle, telephoto).

6. Now, without changing anything but the lens aperture, take the identical picture with the lens open $\frac{1}{2}$ stop larger. Continue this bracketed series of exposures for 1 full stop larger aperture, then 1-$\frac{1}{2}$ stops larger, and finally $\frac{1}{2}$ stop smaller.

7. Repeat steps 4,5,6, above, for other scenes.

8. Process the film in your normal manner, or send it to your usual processing lab. Then, using your standard viewing conditions, select the exposure for each scene that you deem correct.

9. Compare the aperture used for your correct test exposure to the aperture indicated opposite the 10-ft mark on the flash calculator scale. If they differ, note by how much. For example, your tests may indicate an aperture $\frac{1}{2}$ stop larger than the calculator indicates. For all future flash pictures at any distance, apply this correction to all apertures on the calculator dial.

10. If there is no calculator scale on the flash, make your own distance-vs.-aperture table. Just take the aperture used for your correct test exposure and multiply it by 10. This is your guide number (GN) for that system for that ISO film speed. To determine the aperture at any distance, just divide the guide number by the distance; the quotient is the f-number.

11. The guide number (GN_2) for any other film speed (ISO_2) may be found by using your test film speed (ISO_1) and your test-determined guide number (GN_1). Use this formula:

$$GN_2 = GN_1 \left(\sqrt{\frac{ISO_2}{ISO_1}} \right)$$

12. If the manual flash has a variable power control, at $\frac{1}{2}$ power multiply the guide number for full power by 0.7. At $\frac{1}{4}$ power multiply by 0.5, at $\frac{1}{8}$ power by 0.35.

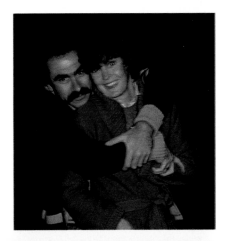

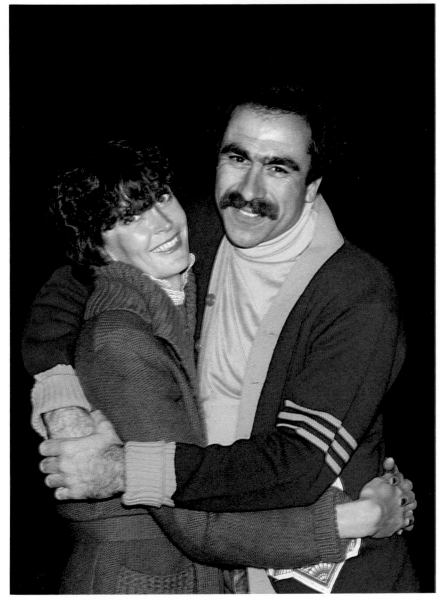

*The guide number of a manual flash unit is determined with a set of average conditions—usually a small room with light-toned walls and ceiling. Outdoors at night or indoors in a large area, there are no extra surfaces to reflect the flash back at the subject. Basing your exposure solely on the guide number or the flash calculator will very likely give underexposure (top photo). Allow ¹/₂ to 1 stop extra exposure with such subjects, **bottom**.*

MANUAL FLASH CONSIDERATIONS

Exposure in the manual mode is based on a particular guide number, which, as stated earlier, is only a guide. In general, it usually assumes a room with a white ceiling 8 to 9 feet high and possibly one or more light-colored walls reasonably near the subject. Walls and ceilings pick up light spilled past the subject and reflect it back to enhance the overall level of illumination.

Photographing under significantly different circumstances, such as outdoors or in a large arena, will usually require ¹/₂ to 1 full stop or more additional compensation.

And subjects that are unusually dark or unusually light usually require ¹/₂ to 1 full stop more, or less, respectively, than indicated by straight guide number calculations.

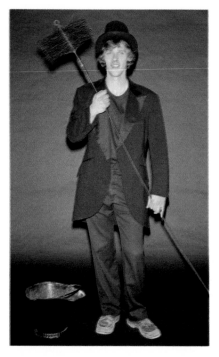 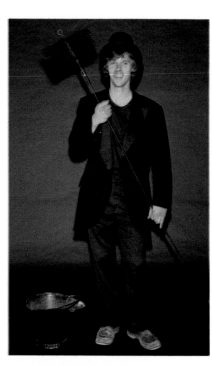

Extremely dark subjects will not reflect much light from a flash. The sensor of an automatic or dedicated flash unit will cause overexposure unless you compensate. Again, bracket with slide film. Start by decreasing exposure at least ¹/₂ stop.

*Faced with the light-toned scene above, an automatic flash sensor cut the power prematurely which underexposed the subject, **left**. For very light subjects, it's wise to bracket exposures, especially with slide film, but you should usually allow at least ¹/₂ to 1 stop more exposure. A manual flash unit will be unaffected by subject brightness.*

AUTOMATIC AND DEDICATED FLASH CONSIDERATIONS

Automatic and dedicated flash sensors read the light coming back from the scene and govern the flash output so as to produce properly exposed medium tones. If the majority (of the area) of the scene is medium-toned, or if the average of the scene's components is equivalent to a medium tone, automatic exposure will be correct.

It is obvious now, that with the flash's single, blind desire to make everything a medium tone, it will produce unacceptable exposures when it encounters subjects you do *not* want to come out medium-toned.

Similarly, the flash sensor is not smart enough to expose properly an object that takes up only a small portion of the field of view. It doesn't know what is an important subject and what is distant background.

Correct automatic exposure in these special situations can be achieved by first realizing that the scene can fool the sensor. Next, decide whether, without compensation, the picture would be too light or too dark. Then close or open, respectively, the camera lens instead of using the exact aperture suggested by the flash. Seldom is compensation by more than 1 or 1¹/₂ stops required; bracket exposures if in doubt.

Experience gained through trial and error, and careful analysis of results—enhanced by detailed notes—will be the best way to learn how much to override the automatic sensor.

DIFFICULT SITUATIONS

Sensors and guide numbers produce excellent flash exposures in most cases. But just as in-camera or hand-held exposure meters can be fooled by circumstances such as backlighting or light or dark subjects, there are fairly common situations in flash photography that may lead to poorly exposed or poorly lighted flash pictures.

Bracket exposures for tricky situations. Take the first picture at the aperture you think will give the best exposure. Then take additional pictures at apertures 1 stop smaller and 1 stop larger.

Aiming a flash unit at a reflective surface will give an unattractive result with any flash unit. An automatic flash unit will sense the reflected light and cut off early giving underexposure. Avoid glaring reflections of the flash (top photo) by shooting at an angle to the subject instead of head-on.

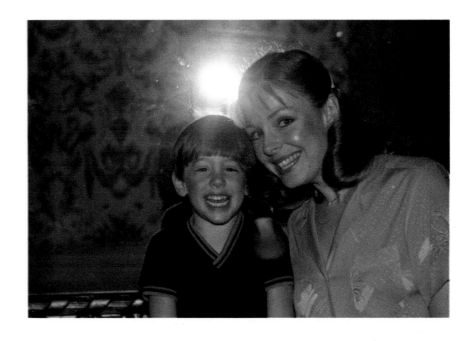

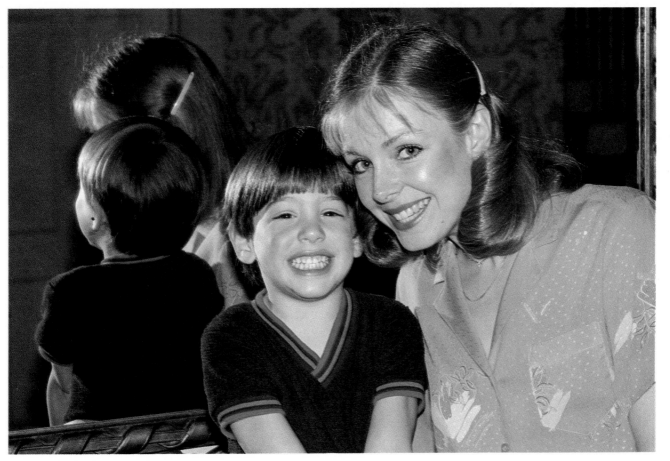

Basic off-camera operation

Removing your flash unit from its customary direct camera connection offers myriad possibilities for pleasing effects. On-camera flash provides a flat illumination that can be rather harsh. When your flash is off the camera, you can create illumination that gives shadows for form or that is reflect for a softer quality.

OFF-CAMERA FLASH

While on-camera flash is fast and convenient, considerable improvement in modeling—subject shape, texture, and general appearance created by the light—frequently occurs when you position the flash away from the camera. The goal is to have the light falling on the subject more from the side, top, or even bottom than directly from the front.

*Flash on-camera tends to give flat lighting with no relief for the form of the subject, **left.** Placing the flash off to one side and somewhat higher than the camera gives interesting shadows that develop a three-dimensional appearance, **right.***

EXPOSURE CONSIDERATIONS

Manual Operation

Because the guide-number system is based on flash-to-subject distance, you need only determine that distance and then select the lens aperture indicated (see page 24).

Automatic Units

In most situations, an automatic flash placed away from the camera and aimed directly at the subject can be operated in the same manner as if it were on the camera. However, make certain that the flash sensor is accurately aimed at the subject, and the flash-to-subject distance is within the allowable automatic range.

Note that the area covered by a particular flash, or a flash equipped with an auxiliary-beam director lens (see pages 30-35), assumes that the flash is mounted on or very near the camera. If the off-camera *flash*-to-subject distance is less than the *camera*-to-subject distance, the field seen by the camera lens will not be completely illuminated. (This may be used to creative advantage.)

A second method of automatic exposure is available if the flash has pro-visions for remote sensor. The sensor is placed on the camera, but connected via a special extension cord to the off-camera flash. Regardless of the flash position, the sensor will read the light getting to the lens. Here, too, don't place the flash outside the manufacturer's recommended flash-to-subject range.

There are two main advantages to the remote sensor. First, aiming of the flash is not as critical, and second, if the flash is placed to the side of the subject, or overhead, the sensor at the camera will not be influenced by the background or subject that doesn't appear in the picture.

Dedicated Units

If the flash sensor is inside the camera, the flash may be placed anywhere. However, a special extension cord for *your* dedicated flash/camera combination must be used, and the flash cannot be placed outside the manufacturer's recommended flash-to-subject range.

If the sensor is on the flash, the same special extension cord will be required, but follow the procedure for regular automatic units.

*When removing your automatic flash from the camera, make sure that the sensor can see the same subject that the camera lens sees. With a flash-mounted sensor, the angle between flash and camera, **below top,** should not be too great or the sensor will see a different scene than the film. A remote sensor attached to the camera, **below middle,** will give a true reading as will the film-plane-mounted sensor of a dedicated system, **below bottom**.*

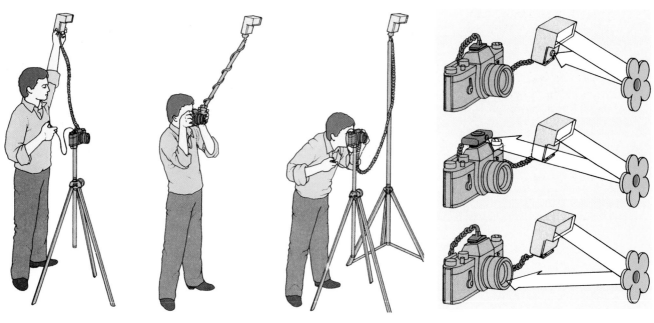

MECHANICAL CONSIDERATIONS

The most convenient way to position the flash for bounce, side, or other indirect illumination is to remove it from the top of the camera and mount it on a bracket or grip. Regardless of camera orientation (horizontal or vertical) a properly made bracket will allow you to aim the flash at a ceiling, back or side wall, or reflector card.

Brackets with quick-disconnect features permit you to position the flash quickly at a high angle so that dark shadows disappear behind the subject. Similarly you can aim the flash at an angle to the subject for more modeling, or aim it from the side for dramatic cross lighting and strong texture. In close-up photography it is also important to be able to remove the flash from the camera and position it near the lens.

Brackets can also eliminate an occasional problem associated with direct flash color photography. When a flash is mounted too close to the camera lens, direct flash photographs of people may show red eyes. These red spots in the person's pupils are actually an image of the retina (rear) of the eye illuminated by light going directly into the eye and reflecting directly back to the camera lens. With the flash mounted on a bracket, the light enters the eye at an angle, and exits at an angle outside the field of view of the camera lens; this usually eliminates the possibility of red eye.

Many advanced automatic flash techniques are possible only if the sensor, normally located on the front of the flash, can be removed, as shown above, and placed on the camera. Then the flash can be aimed anywhere, while the sensor remains pointed at the subject. (With TTL flash systems a removable sensor on the flash is unnecessary since there is already a sensor in the camera body.

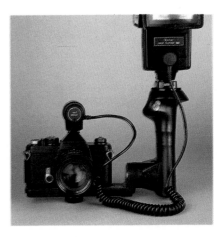

Placing the flash on a grip offers the greatest versatility for positioning it. A special remote sensor cord is required between the flash and the sensor, the latter now installed in the camera's flash shoe.

A support for the flash, be it a stand or another person, frees you to concentrate on the photography.

Though the camera may feel unsteady when held with one hand, the duration of the flash is usually short enough to freeze all but the most severe camera movement.

BOUNCE FLASH

Small light sources produce hard shadows, locally flat lighting, and illumination that rapidly falls off in intensity with distance. And for all but tiny close-up subjects, a flash head can be considered a "small" source.

Off-camera direct flash mitigates some of the unfavorable qualities of direct, on-camera flash, but direct light from a small source, on or off the camera, is still harsh. It cannot be used to illuminate a scene evenly with substantial front-to-back depth, and it never looks like natural light—it always looks like flash.

For every difficulty, there is usually a solution. If the flash is aimed not at the subject but at a large surface such as a wall, ceiling, or cardboard reflector, that large surface now becomes the source. The scene is then bathed with soft, broad illumination that falls on subjects from many directions. And because it comes from the side or top, and not directly from in front, shapes and textures are nicely defined.

Furthermore, light bounced off a ceiling simulates the indoor overhead illumination with which we are so familiar. Similarly, light bounced off a wall falls on the subject in the same beautiful manner as soft, indirect light from a window. Bounce flash photography looks more believable.

When photographed with direct flash, **top,** *this scene displays characteristic direct flash problems: harsh, flat lighting and uneven exposure from foreground to background. The same scene,* **bottom,** *photographed with bounce flash is far superior. Exposure is much more uniform and the quality of light is more natural and flattering.*

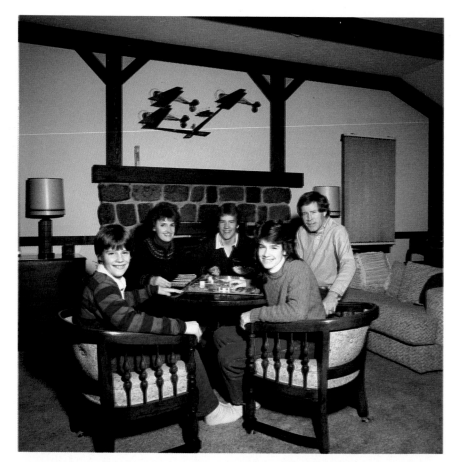

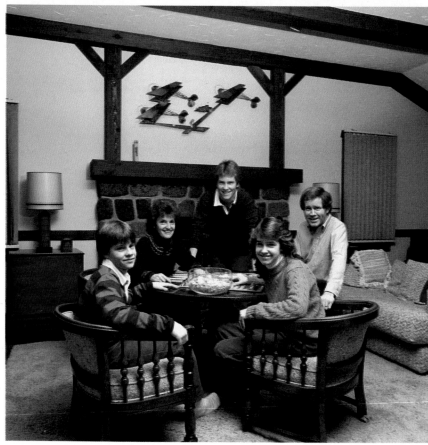

Pleasant portrait lighting was achieved by bouncing flash off the white wall at the right of the photographer. Because the patch of light on the wall was far larger than the size of the flash head, the light falling on the model's face was much softer than direct flash illumination. Also, the light coming from the side, rather than straight on, produced a better sense of roundness and three-dimensionality.

Bouncing your flash off the ceiling or a nearby wall will help to spread out the light to cover a large area as you see at right. Because the bounce surface becomes a large source of illumination, the light reflected from it is much more gentle than light from direct flash. Fast films, such as KODACOLOR VR 400 Film, work best for bounce flash pictures involving large areas because they permit smaller lens apertures, which, in turn, give more depth of field.

POSITIONING THE FLASH

The method used to position the flash for bouncing depends on your flash model and how it is normally attached to or next to the camera. One or all of the following techniques will work with any flash.

If the flash is not designed for a camera with through-the-lens flash metering, and if it does not have a removable sensor or a tilting head, it can be used for bounce flash only in its manual mode.

The tilting head on many flash units makes bounce flash convenient since the flash can remain seated in the camera shoe and therefore requires no additional connector cord. However many flash units, such as the one shown here, pivot only on a horizontal axis, which restricts horizontal pictures to ceiling bounce (you can't use wall bounce), and restricts vertical pictures to wall bounce (you can't use ceiling bounce).

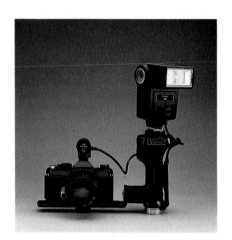

A flash mounted on a pivoting grip can be positioned in any orientation to take advantage of a variety of bounce surfaces regardless of the ability of the flash itself to pivot. All dedicated systems will require a special cord between the camera's hot shoe and the flash. Automatic (sensor on flash) systems will only work if the sensor can be pointed at the subject.

Some flash units, such as this one, have both vertical and horizontal tilt axes. Bounce flash is then possible at almost all common angles, regardless of camera orientation, and without the need to remove the flash from the camera or to use a connecting cord. However, some photographers still prefer to mount the flash on a grip so that they can bounce light off walls behind themselves, or use direct flash held off to one side or high above the subject.

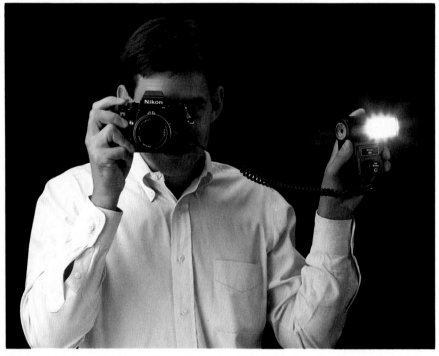

Needing a bounce angle beyond the capabilities of the flash tilt axis, you can hold the flash in one hand, the camera in the other, and connect the two with the appropriate cord for automatic or dedicated operation. Again, the sensor must face the subject on automatic (sensor-on-flash) systems. Or set the flash to manual. As noted earlier, the flash will freeze any camera motion even though your one-handed camera support may feel somewhat wobbly.

The Bounce Surface

Select a bounce surface appropriate for the subject. If the flash is too close to the reflector, the light will not have sufficient distance to spread out and become a large source. Conversely, if too far, the light may spread out more than the subject requires, wasting illumination.

Ceilings are traditional bounce surfaces, but don't hesitate to use walls, a shade or blinds pulled down over a window, or even a cardboard reflector or an overcoat. In all cases, the bounce surface must be light in tone, and, for proper color rendition, the surface should be white, slightly off-white, or gray. Unusual color effects result from bouncing off a colored surface.

For normal color rendition of your subject, use a neutral colored bounce surface. Don't hesitate to bounce your flash off extravagant colors for special effects. Light-toned surfaces, incidentally, will reflect more light than dark surfaces. By bouncing his flash off the orange wall to his left, the photographer gave an orange cast to the woman's face.

Aiming the Flash

The flash head must be angled so that light reflected from the bounce surface will fall where you want it. As the diagram shows, this is best accomplished by aiming the flash head at a point midway between flash and subject. Unsuccessful bounce flash pictures can often be traced to careless aiming—the light falls in front of or behind the subject. Particularly with flash mounted on the camera, it is easy to change the aim point of the flash head accidentally as the camera is moved for desired composition. Make sure also that direct flash doesn't accidentally spill onto the subject. Be careful!

Aim your flash carefully so that the beam of reflected light illuminates your subject rather than the background. If your flash unit has a confidence light, you'll know immediately if you've aimed the flash correctly, and if there's enough light for good exposure. For the photo at left, the flash was incorrectly aimed.

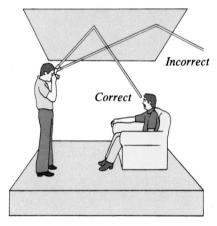

Incorrect

Correct

Operating Considerations

The desirable qualities of bounce flash are obtained at the cost of:

1. significantly limited range when compared with direct flash.

2. the need to use relatively large apertures, thereby limiting depth of field, and

3. somewhat more complicated exposure considerations.

Bouncing the light weakens its intensity at the subject. The bounce surface, even if white, absorbs some light energy, and, more significantly, scatters the light in directions other than toward the subject.

This diminished brightness dictates larger apertures. And whatever the flash unit's range for direct flash, it will be greatly diminished when used for bounce. This is one case where high-power flash equipment and/or fast film can be extremely helpful.

To lighten shadows under your subject's eyes, tape a piece of white cardboard (an index card) to the flash so it extends about 2 inches beyond the flash head. Some of the light from the flash will be bounced off the card directly at the subject's eyes.

BOUNCE FLASH EXPOSURE

Automatic Mode

Automatic mode operation is only possible with bounce flash if the flash sensor can, regardless of flash head position, be aimed toward the subject from the camera position. (If it cannot, use the manual mode, described on the next page.) This requires a flash with either a remote sensor, removable from the main unit, which may be placed on the camera or a sensor mounted on the body of the flash which always faces forward, regardless of flash position. Dedicated flash units that rely on a sensor inside the camera fall into the first category. Those with the sensor on the flash may only be used for bounce in their automatic mode if the sensor can be kept aimed at the subject.

Other than the limitations just mentioned, and those on page 42, automatic sensors generally provide correct exposures in bounce applications. However, underexposure does occur frequently because the power required may exceed the capabilities of the flash. The long flash-to-subject distance, plus the absorption and scattering losses from the bounce surface can lead to insufficient illumination if:

1. the flash unit is small.

2. film speed is low (ISO 25, 64, or even 100)

3. bounce distance is long (high ceilings and/or distant subjects),

4. bounce surface is a poor reflector (non-white), and

5. any combination of these factors.

A confidence light (that shows if there's enough flash light for good exposure) will provide some help here.

It is important to note that the flash manufacturer's suggested near and far limits of automatic operation are specified for direct flash only. Using bounce techniques, both limits decrease by approximately 50%.

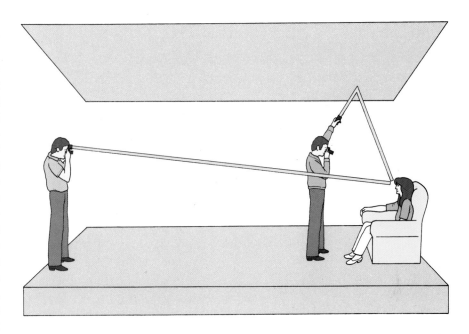

When light from the flash strikes the bounce surface and spreads out, two phenomena occur that require exposure increase over direct flash. First, the bounce surface absorbs some of the light. Second, because the bounce surface scatters the light into a wider pattern, the intensity of the light reaching the subject is lowered. Generally, you'll need to photograph from much closer distances than the maximum distance recommended for your flash unit.

To assure properly exposed bounce flash pictures with an automatic flash, do the following:

1. Sensors with settings for various lens apertures should be set for the mode that gives the largest aperture. When subject, flash, and bounce surface are only a few feet from each other, this is usually not necessary. By using two or more flash units, each aimed at the subject from a different angle, you can achieve both high brightness and strong, dramatic effects. (See pages 62-71.).

2. The total distance from flash to bounce surface to subject should not be more than about 50% of the maximum allowed direct flash distance. (It's wise to practice estimating distances or focusing on the bounce point from the camera and subject positions and then add the total.)

3. If so equipped, check the flash's confidence or sufficient exposure indicator light. If it doesn't glow immediately after firing the flash, move the flash and/or the subject closer to the bounce surface.

Remember that automatic flash operation dictates a lens aperture for a particular film speed. With moderate- and high-speed films, the largest allowable aperture for automatic operation may be $f/4$ or even $f/5.6$. Yet the bounce situation may require $f/2.8$ or $f/2$. Switching to the manual mode, as shown on page 54, permits use of larger apertures and can produce successful results where automatic operation would not.

Manual Mode

With modification, the guide number system for flash exposure works quite well for bounce applications:

1. Carefully estimate the distance from the flash to bounce surface to the subject. Then, use this distance to obtain the corresponding lens aperture as you would for direct flash.

2. Now open the lens approximately 2 stops more than determined by step 1 above. Non-white reflectors and/or very long (over 30 feet) distances may require $2^1/_2$ or even 3 stops additional compensation. Very short distances—less than 6 feet—may only need 1 stop compensation. Practice in a variety of situations and circumstances is advised and gives you a better feel for the amount to open the lens.

Note: When the flash is used at close distances with high-speed films, the required aperture (manual mode) for direct flash is often smaller than the smallest *f*-stop. Bounce flash can often overcome that problem.

While the exposure techniques explained above do work well, those contemplating frequent and/or critical bounce flash photography are advised to consider a flash meter. (See page 59.) The meter accurately measures the actual flash illumination on the subject, regardless of distance or bounce surface characteristics.

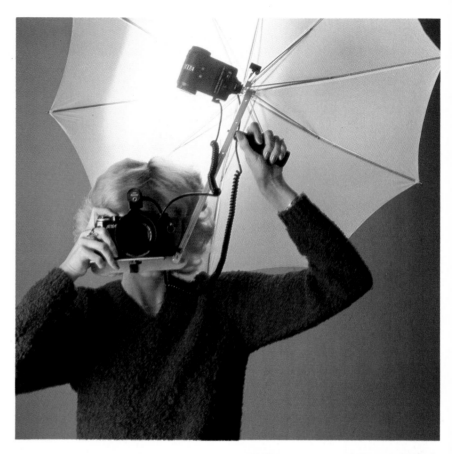

BOUNCING INTO UMBRELLAS

Flash bounced from walls, ceilings, and other flat reflectors is extremely effective for room-size situations, and even portraits and still lifes. However, these bounce surfaces leave much to be desired in the way of directional control. They also waste considerable light energy, and they may have an undesirable color. What's more, light-colored walls and ceilings frequently either do not exist at all or are too far from the subject to be of much use.

A photographic umbrella, used to reflect light from a flash, provides the soft luminosity of a large light source. Umbrella illumination has good directional control, proper color characteristics, and wastes far less light than a flat reflector. An umbrella, stand, and flash also make a reasonable portable package with sophisticated capabilities.

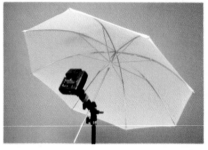

Bouncing your flash into an umbrella is an excellent way to soften the harsh light of direct flash and to control the direction and the intensity of the illumination. There are portable umbrella rigs available, as well as units that will mount on a separate stand.

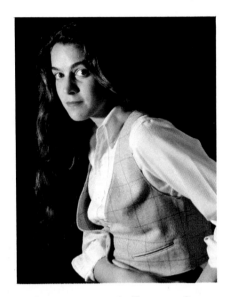

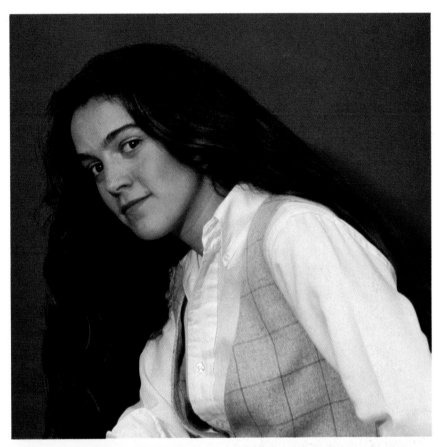

*In this comparison of off-camera direct flash, **above,** ceiling bounce flash, **top right**, and umbrella-bounce flash, **bottom**, note how the umbrella offers the best features of each of the other methods. The illumination is directional enough to give some form to the model's features, yet maintains some of the soft quality of the ceiling-bounce shot.*

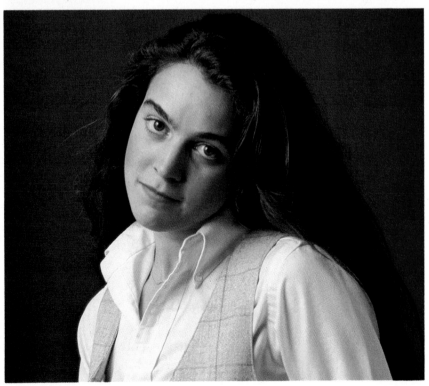

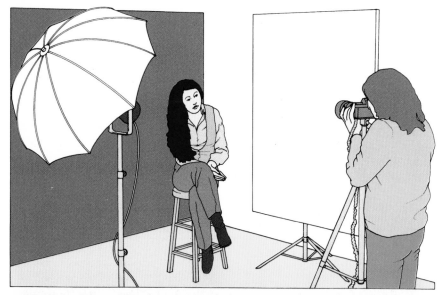

You can add an extra element to any off-camera flash photography by including a simple reflector to brighten shadows. The reflected light will always be less intense than the main light.

Exposure with Umbrellas

Because the flash is mounted completely away from the camera, automatic exposure operation is only possible if the flash unit has a remote sensor or if you are using a TTL flash system. (See page 47).

In manual mode, the modified guide-number system described for bounce flash from flat surfaces, (page 54), can be used, though exposure compensation can vary from 1 to 2 stops, depending on umbrella material. Of course the flash-to-subject distance is the sum of the flash-to-umbrella plus umbrella-to-subject distances.

Exposure with umbrellas may also be determined from photographic tests. Make a series of pictures of an average subject with the umbrella at various distances, say 2.8, 4, 5.6, 8 and 11 feet. (These numbers look suspiciously like *f*-stops. The result is similar. You get half as much light at 11 feet as you do at 8 feet. This relationship makes future calculations easier.) For each distance bracket your exposures. After processing, choose the correct exposures and, in general, use them for all photography with the umbrella at the corresponding distances. You will find that umbrella placement is not very critical to correct exposure, which gives you the freedom to angle it differently with respect to the subject and to make small changes in umbrella-to-subject distance without worrying about exposure alterations.

BARE-BULB FLASH

A number of professional electronic flash units have provisions for photographing with a bare flash bulb. Because there is no reflector behind, nor lens in front of the tube, light is emitted in all directions.

When used in a small-to-moderate-size room, the subject receives both direct light from the tube and fill-in bounce illumination reflected back from the walls, ceiling, and floor. Lighting quality falls between hard, direct flash and soft, but directional, bounce flash.

Bare flash tubes are generally available only on manually operated equipment, so exposure calculations must be via the guide-number system.

Bare-bulb flash light reflects off all the surfaces in a scene so that the subject receives illumination from all directions as well as from the flash itself. This method provides even lighting as well as some shadows for modeling.

Reliable guide numbers are usually provided by the manufacturer, and they are based on the fact that the *direct* light to the subject determines the actual exposure. Stray, bounced light fills in harsh shadows and provides ambient illumination around the subject, but usually does not contribute noticeably to the light intensity on the subject.

Fine tuning

For direct- or bounce-flash photography, flash or camera sensors will do a good job. But for more sophisticated use of flash, including multiple flash, special-effects flash, and fill-in flash, a flash meter or instant-film are a necessity. Today, flash meters are no more expensive than conventional ambient-light exposure meters, and are just as easy to operate. The serious flash photographer will find that use of a meter will create more confidence and better pictures.

Exposure for bounce lighting with a single, manually operated flash is best determined by a flash meter. Similarly, when a number of automatic flash units are used to illuminate a large area, they generally must be set on manual. Here again, a meter is used to check exposure and to ensure even illumination with the desired lighting ratio.

FLASH METERS

Using a flash meter takes the guesswork out of multiple-flash photography. By aiming the meter back at the camera, the photographer will get a fairly accurate incident reading from test firing the flash setup. At right, the main light is closest to the subject. The weaker fill flash is back near the camera. The meter accounts for any additive exposure effect from overlapping light sources. In this example, the connection between camera and flash units is hard-wired. The test is made by firing an empty camera. With a slave cell on the main flash, the photographer could make the test by firing the fill flash manually without

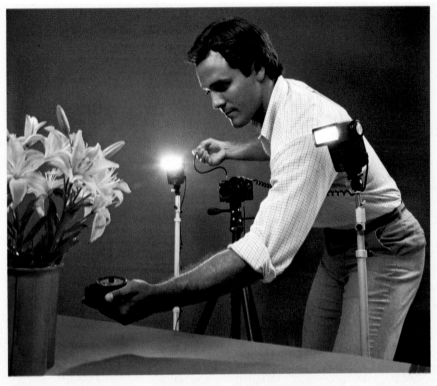

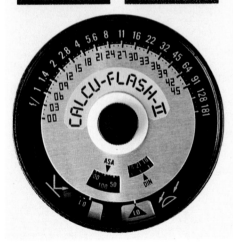

touching the shutter release. Firing a flash setup two or more times will provide more light for large or distant subjects or for greater depth of field. The meter at left will measure accumulated flashes. Every time the setup is fired, the readout value

increases. Matching the final readout number to the f-number scale will give the f-stop for the total light output. In this example the setup was fired twice. The first flash would have required f/11. The second flash allowed f/16 for greater depth of field.

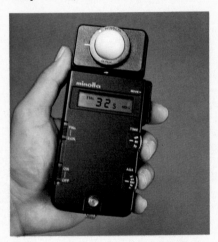

The sophisticated meter shown above gives a direct LCD readout of the f-number required for the film speed and the power of the flash setup.

The meter above indicates flash output by lighting one of the red wedges. Matching the lighted wedge with the adjacent scale gives the f-number to set on the camera.

Flash meters can indicate proper exposure in situations where automatic flash sensors are fooled by subjects that do not have average tonality, or that occupy only a small portion of the frame. This model in white posed against a white wall would cause an automatic flash sensor to underexpose the picture (see page 42). But by switching the flash to manual and taking an incident meter reading, the exposure can be based on the actual amount of light falling on the subject, not on the amount of light reflecting from an abnormally bright scene.

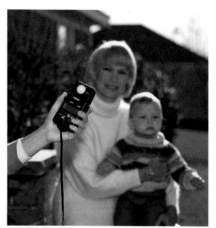

A flash meter can also be used to help you determine the camera and flash settings needed for fill-in flash. See pages 76–78 for details.

In this example, a flash on the camera and two additional units placed around the room were all bounced off the ceiling to provide soft, even illumination over a relatively large area. The remote units were fired by slave triggers, and all equipment switched to manual. An incident-light reading from a flash meter indicated the appropriate lens aperture. Additional readings were taken around the area being photographed to check that the position and angle of each flash produced uniform lighting.

INSTANT FILM TESTING

Even when using guide numbers and flash meters, complicated multiple-flash photography is difficult to accomplish consistently to critical standards with small portable equipment. Why? Because you can't see what you're doing until the film is processed. Is light spilling where it's unwanted? Are shadows too dark or too light? Is there an obnoxious reflection from jewelry, glass, or metal? Are background and subject inseparable—too close in tonality? You might want to test any lighting setup before making an important shot.

Studio photographers avoid these problems in two ways: First they use flash units equipped with modeling lights. Modeling lights are relatively weak incandescent bulbs located close to the flash tube. Operating from 115-volt ac current, they generate a visible light pattern equal in quality, but not in brightness, to the flash illumination. The ratios among the modeling lights are the same as among the stronger flash units, so that lighting effects can be clearly seen at the camera position. Second, studio photographers make instant-film tests before committing themselves to shooting the final film.

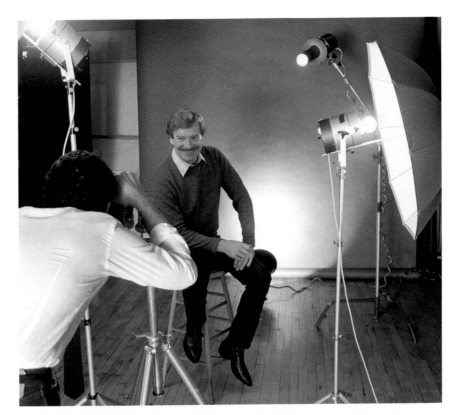

Some professional-level portable flash equipment does accept add-on modeling lights for indoor situations to make accurate multiple-light control much easier.

Because the effects of different light placement and exposure are often difficult to predict, it may be handy to make test exposures on instant print film.

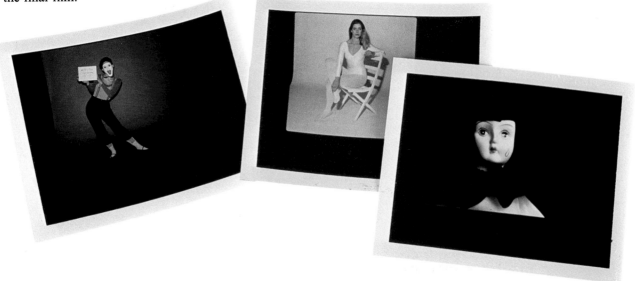

Multiple flash

Having experienced some of the blessings that one flash unit can provide, it's time to turn to the manifold joys of coordinating the output of several units. The possibilities are truly endless, as you'll soon see. For multiple flash, sophisticated units are not necessary. In fact, you may find that operating several rather simple models becomes a pleasurable and rewarding pastime.

With two or more flash units the possible lighting effects are limited only by your imagination.

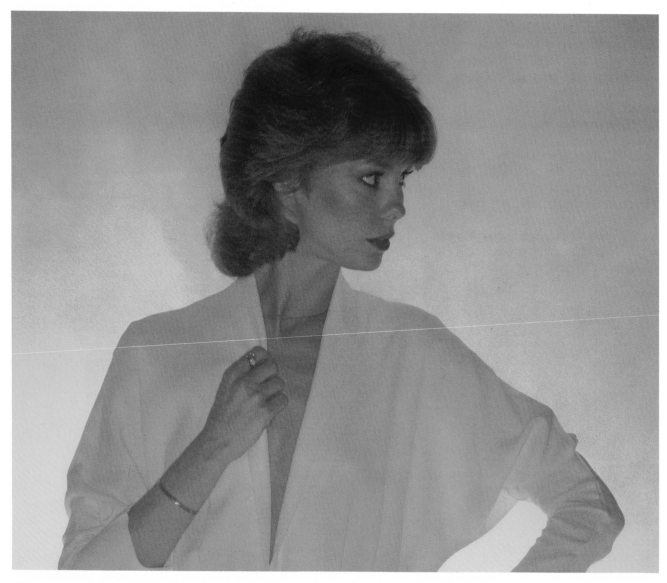

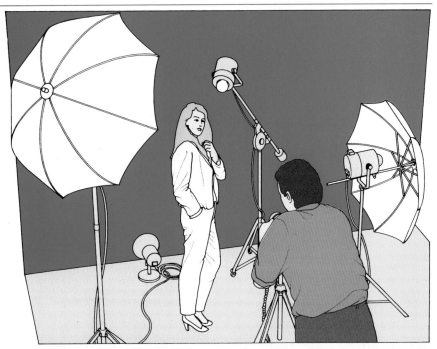

MULTIPLE FLASH UNITS

The directional quality of a single light source, even if bounced or diffused, can cause undesirable one-sided illumination. White or silver cardboard reflectors can be used to fill in shadows somewhat, though with direct flash, certain parts of your subject may still lack adequate detail. A further limitation of bounce or diffused light is that its brightness is relatively weak, and it tends to engulf the entire subject, precluding the possibility of highlighting particular elements or areas. And finally, large scenes just cannot be illuminated adequately, either in intensity or uniformity, with a single electronic flash unit.

These problems can be overcome by using more than one flash. And while multiple flash is usually thought of as multiple *direct* flash, the best images may result from two bounce umbrellas, or three large diffusers, or four units bounced off a ceiling in a large room. In fact, any combination of direct and indirect flash can be used to achieve the picture you want.

Even just two electronic flash units provide considerably greater power and versatility than one, as well as the potential for creative techniques such as rim, back, and background separation lighting. The second unit need not be as powerful nor as sophisticated as the main flash. A very inexpensive, simple electronic flash is frequently the best choice.

A typical placement of four flash units is illustrated at right and above. The umbrella to the left of the photographer provides the main source of light. The small umbrella at the photographer's right fills in shadows created by the main light. The flash above the model helps to separate the model's hair from the background and the small light aimed at the background helps to separate the shadowed right side of the blazer from the dark background.

The photo below was lighted with one flash only from the left side. At right, another flash was added to fill shadows on the right side of the doll. The power in both flash units was adjusted so that the flash on the left provided more light than the closer fill-in flash on the right.

MECHANICS

Triggering Two methods exist to fire multiple flash units simultaneously. The first is the hard-wire method that physically connects extension PC cords from each flash to a multiple connector, which is plugged into the camera flash outlet. Wires that are

easily tripped over and tangled make the hard-wire system a bit inconvenient. Furthermore, interconnecting different models of electronic flash may cause one or more of them to fire indiscriminately, or fail to fire at all when triggered.

A more reliable method requires a slave trigger—often just called a slave. This device is a small photocell that connects with the flash PC cord or hot shoe. If another flash is fired in the vicinity, the photocell fires the flash to which it is connected. (Since light and electricity both travel at 186,000 miles per second, the delay between firing the main unit and the slave flash 25 feet away would be only 0.000000025 second!) At least one flash unit must be wired to the camera's flash outlet or hot shoe, and the slave triggers must be aimed to receive the light from the primary flash.

There are myriad ways of attaching portable flash units to surfaces other than the camera hot shoe, including spring clamps, C-clamps, and tripod connectors.

Mounting Multiple flash requires some means of supporting and positioning the additional flash units. Various stands, clamps, and swivels are shown in the accompanying illustration, though many successful photographers have been taken with flash units inelegantly taped to doors, chair backs, and shelves. What is important is secure placement and accurate aiming.

Although two flash units may be easily connected with hard wire and multiple socket arrangements, photoelectric slave cells are tidier and usually more reliable. The slave units with two-prong plugs are for professional flash units and power supplies.

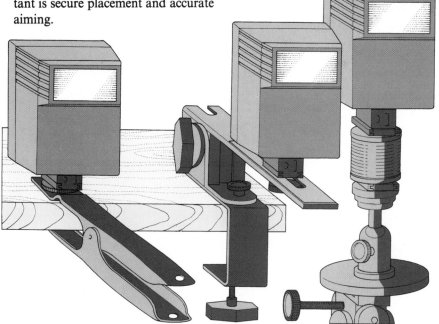

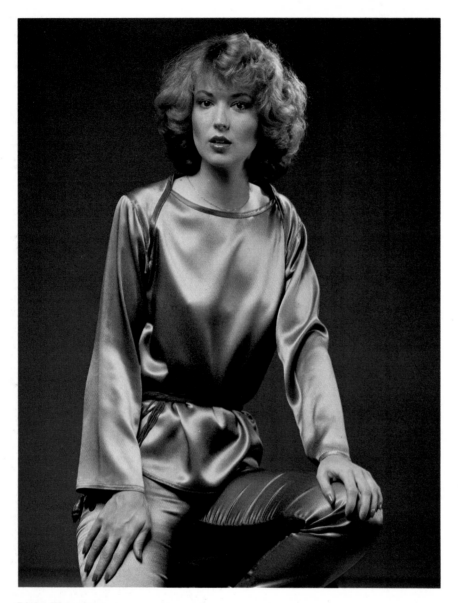

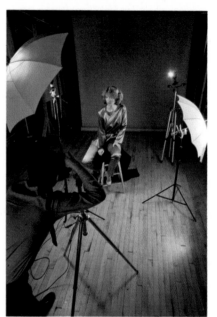

Main light at left and above; fill light at right and lower; light behind used to brighten background.

Light Placement

Endless combinations of light placement and lighting effects are possible with two or more flash units. The illustrations in this chapter present some of the possibilities—experimentation will suggest others. Note that cardboard reflectors can be quite helpful for filling in shadows and brightening dark corners or sides.

There is a temptation to aim several flash units directly at the subject, so that the second unit can fill in the harsh shadows caused by the first. The idea is to maintain the brightness inherent in direct flash and get more pleasing illumination. Unfortunately, *two* hard shadows are usually created by the two units. Don't hesitate to diffuse or bounce one or more of the main lights and use other flash units to illuminate the background or edges of the subject.

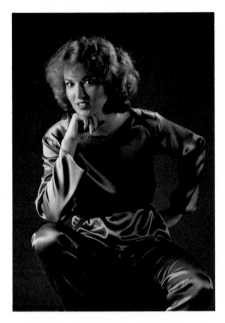

Main light at left, fill light at right, and hair light still behind on the right.

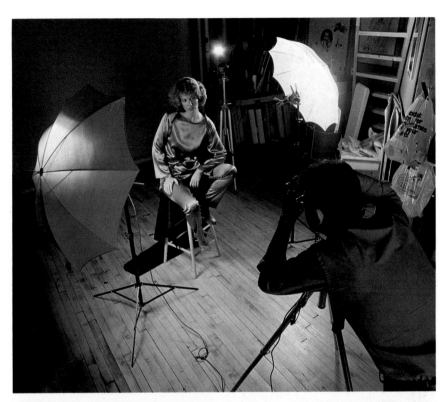

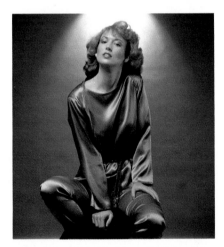

Main light left and above; fill light right and at head level; hair light above and behind.

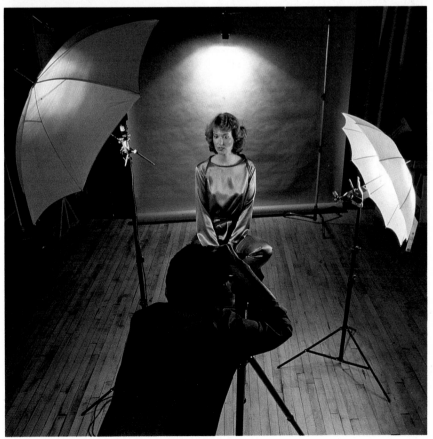

LIGHTING RATIOS

The brightness ratio between the main light and the fill light determines the lighting effects on your subject. How dark should the shadows be in comparison to the highlight (lighted) parts of the scene? A ratio of 8:1 (brightness of the main light to brightness of the fill light) is equal to a 3-stop difference and is fairly dramatic. A 2:1 ratio is relatively bland. Accompanying photographs illustrate various ratios; they are worthwhile studying to get a feel for balancing multiple lights.

Note that with color transparency films, it is advisable to use a somewhat lower lighting ratio than when negative materials are used. Transparencies have higher inherent contrast and, unlike prints from negatives, they cannot be burned-in or dodged in the darkroom to bring out deep shadows or overexposed highlights.

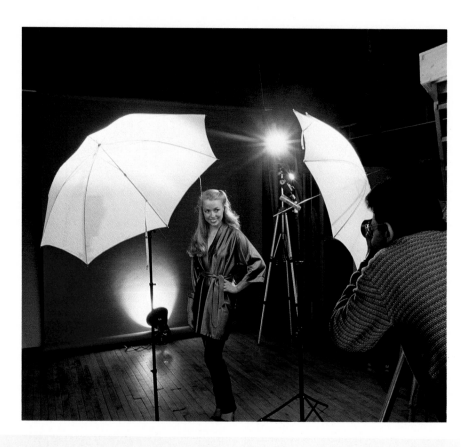

CONTROLLING INTENSITY

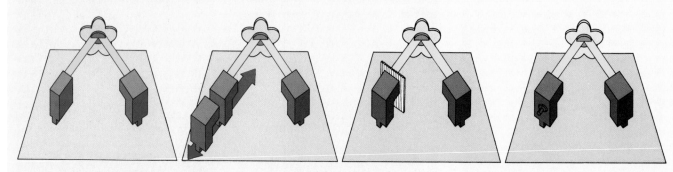

1. Each flash unit has its own maximum power output. Output varies by approximately 4 stops, or a ratio of 16:1 from the weakest to the most powerful portable equipment. Place your units according to their maximum output at the manual setting. Use the most powerful unit for the main light. Use a weaker unit for the fill light. Determine the difference in output and position for desired fill ratio.

2. With the flash set to manual, flash-to-subject distance controls intensity at the subject. Because light intensity decreases in proportion to the square of increased distance, placing a flash twice as far from the subject as another flash of equal output results in a 4:1 flash ratio. The farther flash is one fourth as effective in illuminating the subject as the closer flash—a 2-stop difference. When three times as far from the subject, the farther light gives only $1/9$ the intensity—a 9:1 ratio, or 3.2 stops less.

3. Diffusers can be placed over the flash to both decrease intensity and spread the light. And, of course, the light can be bounced off a reflective surface to lower intensity and spread out the light beam.

4. Some sophisticated flash units have add-on or built-in power output ratio controls. They permit the output (in manual mode) to be lowered from maximum to various fractions, typically $1/2$, $1/4$, $1/8$, $1/16$ and sometimes even $1/32$.

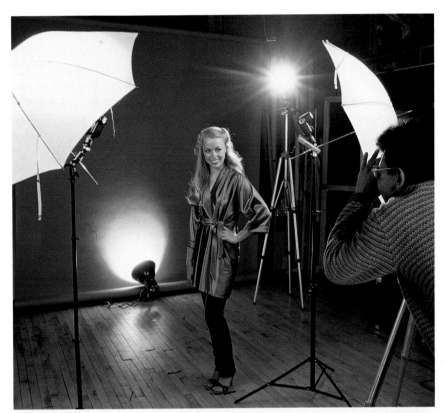

*Placement of the light can alter the ratio of light falling on different sides of the subject. **At top,** lights of equal power were placed at equal distances to achieve a 1:1 ratio (both sides of the subject receive equal illumination). **Above,** a 2:1 ratio was gained by moving the fill light 1.4 times as far from the subject as the main light. **Below,** the fill light was moved twice as far from the subject as the main light for a 4:1 ratio.*

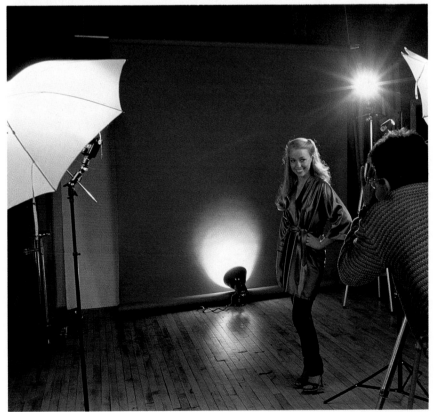

EXPOSURE

Exposure determination for multiple flash lighting is more complicated than for single-source setups. In fact, in almost all situations using more than one flash, automatic exposure control will probably *not* produce satisfactory, or controllable results. Automatic sensors are designed to provide proper main-light exposure, assuming only one source. But when other flash units are present, it is impossible to determine how they will affect the sensor on the main flash, or how the main flash will affect automatic sensors on the auxiliary electronic flash units.

Additionally, you are generally concerned with a particular *ratio* between main and auxiliary lights. Yet, for example, in automatic mode, a flash does not know that for this scene it is supposed to provide low-level, fill-in illumination—it insists on exposing normally. The solution is to operate all units manually, and use the guide numbers or a flash meter.

Overlapping Light

A valid question when using multiple flash is, *"Doesn't an auxiliary flash add to the main light, and if so, shouldn't the lens aperture be closed down?"* The answer in most cases is that the auxiliary illumination is only filling in a shadow, adding a hair or rim light, or illuminating the background. Overlap onto the part of the scene lit by the main light is usually inconsequential. However, if two units are aimed in the same or close to the same direction, then, indeed, their outputs will add. In fact, two flash units are frequently placed together when additional brightness is needed. Two units of equal power at the same distance in manual mode double the light on the subject, permitting a 1-stop smaller aperture. For other combinations of equipment and distance, a flash meter or testing is necessary for acceptable results.

Background Lighting

Frequently an auxiliary flash can be used to light a background, either overall or in a small bright area behind the subject to provide tonal separation between subject and background. To determine proper exposure, consider the background as your subject in the flash-to-subject measurement, then proceed as in steps **2** and **3** below under "Guide-Number System."

GUIDE-NUMBER SYSTEM

1. Position the main light first. If you're using direct flash, divide the guide-number by the flash-to-subject distance to find the lens aperture. For bounced main light, determine the aperture as explained on page 54. Set the camera lens at this aperture.

2. Next, determine the effect and intensity (with respect to the main light) desired from the first auxiliary unit. If it is to have intensity equal to the main light, its guide-number divided by its flash-to-subject distance must equal the aperture determined for the main flash. If you want the auxiliary unit to provide a 2:1 (main-to-fill) ratio—1 stop less intensity than the main light—position the auxiliary flash so its distance divided into its guide-number produces a number which is 1 stop larger than the lens aperture set for the main flash. Similarly, a 4:1 ratio requires

2 stops larger; 8:1, 3 stops; and so forth. If you want the auxiliary light brighter than the main light—let's say a 1:2 ratio or 1 stop brighter—the distance/guide-number division must generate a number 1 stop smaller than the lens aperture setting. A 1:4 ratio requires a number 2 stops smaller.

3. When using auxiliary flash units that have variable power control, first determine the aperture suggested at full power when the flash is positioned conveniently. If that aperture is too small for the desired lighting ratio, don't move the flash. Turn down the power control to $\frac{1}{2}$ for 1 stop less light, to $\frac{1}{4}$ for 2 stops less, to $\frac{1}{8}$ for 3 stops, and to $\frac{1}{16}$ for 4 stops. If the aperture suggested by the placement of the auxiliary flash is too large, move the light closer.

4. Additional auxiliary flash units should be set up, one at a time, as described in *2* or *3* above.

For example: you require a flash-to-fill ratio of 2:1 using two identical flash units of guide-number 50.

Main light

Placing the main light 6 feet from the subject, calculate the required aperture by dividing the guide-number (50) by the flash-to-subject distance (6). The aperture is *f*/8.

Auxiliary light

Follow instruction no. 2, left. You need an indicated aperture of *f*/5.6 (1 stop more than the main light) for a flash-to-fill ratio of 2:1. Therefore, divide the guide-number (50) by the aperture required (*f*/5.6). The result (9) is the flash-to-subject distance in feet.

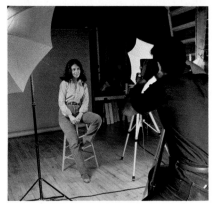

Above: a subject with dark hair is often lost in a dark background.

Left and below: one way to separate the subject from the background is with a light aimed to lighten the background.

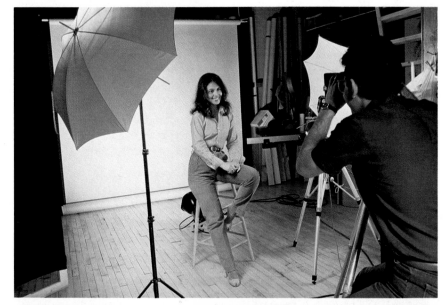

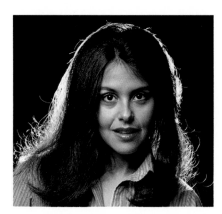

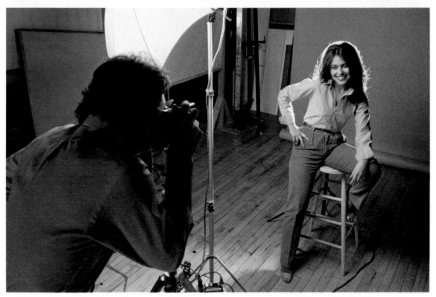

Above and at right: another way to relieve the dark edges of a subject from a dark background is to aim a small light at the subject's hair from behind.

Flash outdoors

Although flash is primarily considered a tool for lighting indoor scenes where ambient light is too dim for successful existing-light photography, you'll find it a useful and even exciting addition outdoors in the daytime or at night.

FILL-IN FLASH

Compared with the human eye, all films have considerably less ability to record detail simultaneously in both very dark shadows and very bright highlight areas. This limitation is somewhat more pronounced in slide films than in negative materials.

Flash can be used to brighten shadow areas so that details become apparent. Flash can also become a creative tool to tone down surroundings and spotlight subjects.

*Outdoor lighting can often be improved with the judicious use of your electronic flash unit. Particularly in a backlighted situation, you'll find that if you expose for the background, your subject becomes a near-silhouette, **top**. If you expose for the subject in shadow, the background will become unattractively overexposed, **middle**. The answer is to set your exposure for the background and add some flash to brighten the shadows on your subject, **bottom**.*

Another case for fill-in flash occurs when your subject is located near a bright light source, such as a lamp or window. When exposure is correct for the subject, **top left,** the background is washed out, and often the subject contrast is noticeably decreased by lens flare. On the other hand, exposing properly for the bright light causes the subject to record on film as a silhouette, **top right.** Fill-in flash helps to balance exposure between background and subject, **bottom.**

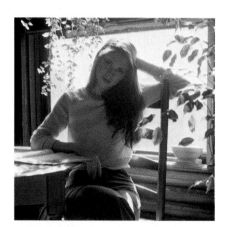

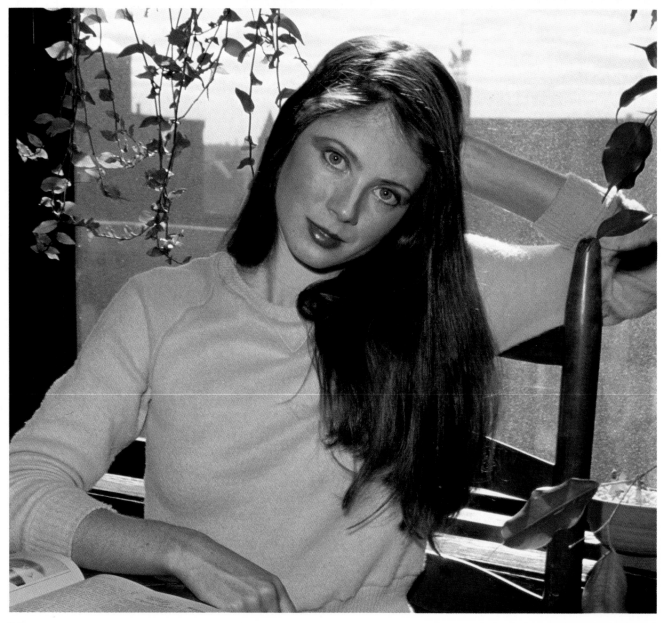

You can create a dramatic image by spotlighting your subject with flash outdoors. Make sure that the sunlight is completely overpowered by the flash.

Equipment

Some care and effort is required to determine exposure for fill-in flash photography. If you are comfortable with the rules of general flash operation, fill-in flash procedures should be easy to follow. But they must be applied in a methodical manner!

Because the lens aperture must be correct for both ambient and flash illumination, fill-in flash is considerably easier if the flash equipment provides a choice of automatic-mode aperture settings or variable power control. And because the selected shutter speeds must be corrected for both ambient and flash illumination, fill-in flash is easier with leaf-shutter speeds. Focal-plane-shutter cameras are typically limited to synchronization speeds of $^1/_{125}$ second *or slower.*

Flash Meters can help determine correct fill-in flash exposure and balance ambient and flash illumination. Automatic electronic flash units generally have a maximum of four allowable *f*-stops which restricts the ability to match the exposure required for the ambient light. But by operating the flash manually and using a flash meter, it is easy to read the flash intensity anywhere in the scene. And flash fill is not restricted to direct illumination. It can be bounced, diffused, or moved to provide the desired quality, direction, and intensity. A flash meter eliminates tedious calculations. Some of the more sophisticated meters read and integrate both flash *and* ambient illumination at various shutter speeds and provide convenient scales to assist in balancing each type of light for the desired effect.

EXPOSURE

1. In all cases, first make an exposure reading with your camera or a handheld meter of the bright ambient light. In our example, **near right,** the photographer is reading the sky, being careful to exclude the sun. Make note of the various combinations of aperture and shutter speed that provide correct exposure. In our reading of the sky, the meter, **far right,** indicates 1/125 sec between *f*/5.6 and *f*/8, or 1/60 sec between *f*/8 and *f*/11, etc.

 Since flash will be used to fill in the shadow areas, the shutter speed chosen must be the *flash sync speed or slower, although below 1/60 sec a tripod is usually required.*

2. Based on the ambient light meter reading, set your camera lens. The meter gives a "normal" reading for the ambient light at this point you may decide, for example, to have the background intentionally dark, in which case set your lens to a smaller aperture than the meter indicates.

3. With the lens aperture fixed, the flash must be set to provide the correct flash exposure at *that* aperture. Decide whether the flash illumination should be darker than, equal to, or lighter than the ambient light. An exact balance between flash and ambient light often looks somewhat unnatural, although with your initial calculations and tests that's a good place to start to avoid confusion. More pleasing results sometimes are obtained when the flash gives about one stop less exposure than the ambient light.

 For automatic flash (sensor on flash).
 See if one of the allowed apertures on the flash closely matches the aperture to which your lens is set (step 2 above). If so, set the flash to the mode for that aperture; the results will give a picture with full flash exposure of the subject. Continuing our example, with a camera having a 1/125 sec sync speed, for the ambient light exposure we chose 1/60 sec with the lens between *f*/8 and *f*/11 (step 1 above). The purple mode on our flash (see photo) also requires an f-stop between *f*/8 and *f*/11, so we can proceed with the picture.

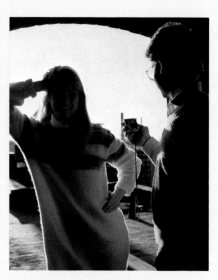

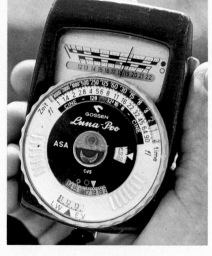

Alternatively, an equivalent ambient light reading is 1/125 sec between *f*/5.6 and *f*/8. That aperture allows the blue mode on our flash to be used (blue mode results in slightly less depth of field, but has a maximum flash distance of 15 ft; purple mode only goes to 10 ft). If we had desired the flash to be more subtle, say one stop weaker than the ambient light, we would have set the camera to 1/60 sec, lens between *f*/8 and *f*/11 (normally exposure for ambient light), but the flash to blue mode. Blue mode requires a lens aperture between *f*/5.6 and *f*/8; since the lens aperture is actually set one stop smaller, the flash illumination will be one stop less than "normal."

If one of the allowed flash apertures does not match the lens aperture, try the next slowest shutter speed and corresponding one-stop smaller lens aperture; this new lens aperture may now match an allowed flash aperture. You may not always be able to do fill-in flash on automatic if the ambient light is very bright, if your flash is small, and/or if it only has one or two allowed apertures.

You can always switch to manual flash for a greater range of apertures.

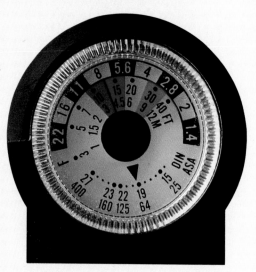

Setting this automatic flash unit to the purple mode indicated that between f/8 and f/11 will give flash fill to equal the brightness of the sunlit background.

For manual flash. For equal ambient and flash illumination, use the flash calculator scale to find the flash-to-subject distance that results in an aperture equal to that set on your camera lens for the ambient light. If there is no calculator scale, remember that *Aperture = guide number ÷ flash-to-subject distance*. In our example the lens is between f/8 and f/11. Looking at the calculator scale on our flash (bottom photo), to use an aperture between f/8 and f/11, the flash-to-subject distance must be 10 ft. If the flash is moved back to 13½ ft, the flash illumination will be one stop less than the ambient light (13½ ft requires between f/5.6 and f/8), which is often desirable in many cases. Some flash units have variable power settings for manual operation. This allows control of the flash brightness without moving the flash. Here a handheld flash meter can be very helpful, permitting accurate control of flash illumination in relation to ambient light; in fact it is the most versatile, accurate method for controlling fill-in flash.

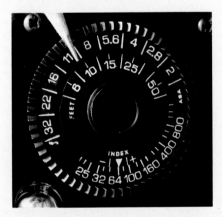

For the aperture given by the exposure meter on the opposite page, the recommended flash-to-subject distance shown on this manual flash calculator is 10 ft, which would give equal exposure to subject and background.

For dedicated automatic flash. Most dedicated systems are somewhat restrictive when it comes to fill-in flash. They usually limit the shutter speed to the sync speed only, which inhibits photographing under low ambient light conditions. Also, because both the ambient and flash illumination are read and controlled through-the-lens, it is difficult to control ambient-to-flash brightness ratio.

However, fill-in flash is still possible, but it is best to consult the camera and flash instructions for your system. Also remember that most dedicated equipment can also be switched to operate as an automatic (sensor on flash) system, in which case follow the suggestions above.

4. Fill-in flash outdoors on very bright days may be a problem with many focal-plane-shutter cameras, which sync with flash at a maximum shutter speed of 1/60 or 1/125 sec. For example, the sunny day exposure for an ISO 100 film is about 1/125 sec at f/16 or 1/60 at f/22. But the smallest aperture allowed by many shoe-mounted flash units for ISO 100 is typically f/11, and at a maximum distance of about 9 ft. Though inconvenient, you could use the flash on manual and hold it close to the subject for adequate brightness at small apertures. Better yet is to use a leaf shutter camera, which typically syncs with flash up to 1/500 sec or one of the new focal-plane-shutter cameras which syncs at 1/250 sec. At 1/250 sec, the lens aperture is f/11, an aperture more likely allowed on a small, automatic flash. Of course, a more powerful flash is another alternative when flash is required at small apertures.

And sometimes with a very strong ambient light and a relatively weak flash, it's just not possible unless you get very close to your subject. Conversely, when the ambient illumination is weak, a relatively large camera aperture is required, whereas the flash may require a medium or even small f-stop. Here, if available, use an automatic flash setting for a larger aperture. If manually operated, move the flash farther from the subject. (You can always change lenses for a bigger subject image.) If variable power, turn down the output. You can also cut flash output by taping white tissue over the flash reflector. Generally, two layers cuts the lighting 1 stop. Naturally, a diffuser, shoot-through umbrella, or bounce card would work as well.

5. To achieve unequal balance between flash and bright-ambient lighting, first decide whether the flash or the bright-ambient area should be normally exposed.

If the bright-ambient area is to be normal, choose one of the available lens apertures for the proper bright-ambient exposure. Now, depending on your equipment, set the flash's automatic aperture, or manual power, or manual distance so that the aperture required for correct flash illumination is 1 or 2 stops larger than the lens aperture set on the camera. Leave the lens aperture set for the bright-ambient light exposure. The photograph will have a normally exposed bright-ambient area and a flash-illuminated area that is 1 or more stops darker.

Conversely, to spotlight the flash-illuminated subject against a darker ambient area, do the following. Set the lens aperture as required by the flash for a normal flash exposure. Now set the shutter speed so that the combination of lens aperture and shutter speed produces an exposure at least 1 stop less than required for a normal rendition of the bright-ambient area.

Lower left photo. As in the middle photo, the camera was set to 1/60 sec between *f*/8 and *f*/11. But here the flash was set for a mode requiring a lens aperture between *f*/2.8 and *f*/4. Since the lens was actually 3 stops smaller than what the flash required, the flash illumination is 3 stops "underexposed" to give a strong feeling of dusk.

Lower right photo. To darken the sky, the camera was set at 1/125 sec between *f*/8 and *f*/11 (one stop less than indicated by an ambient reading of the sky). Next, the flash was set to one of its allowed modes that called for an aperture between *f*/8 and *f*/11. Here the flash illumination is "normal" against a dark background, making the subject stand out dramatically.

Middle photo. Camera exposure based on ambient reading for sky: 1/60 sec, between *f*/8 and *f*/11. However, the automatic flash was intentionally set to a mode that required an aperture between *f*/5.6 and *f*/8, thereby "underexposing" the flash portion of the scene by 1 stop to make a pleasing photograph.

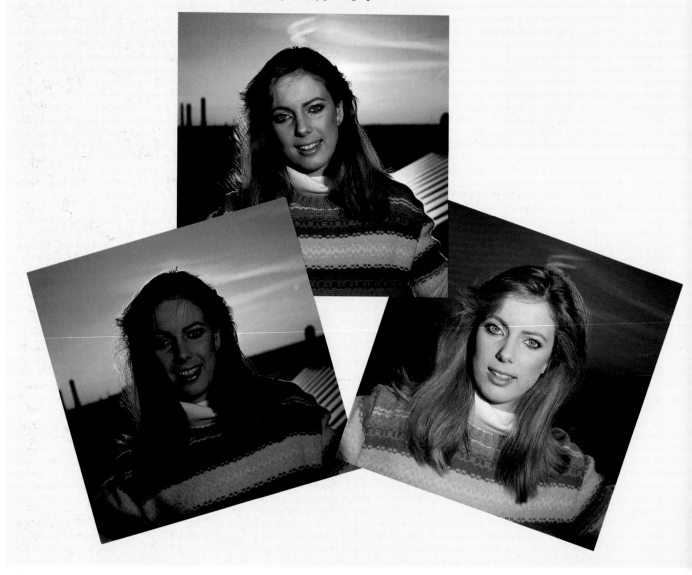

FLASH OUTDOORS AT NIGHT

Photographing outdoors at night is similar to taking pictures in a giant, totally black room. Tremendous potential exists for unusual, often stark visual effects because there are no light-colored ceilings or walls to reflect light—just black, empty space. There's even the opportunity to leave the shutter open in this black space and, totally disconnected from the camera, firing the flash at will, one or more times per frame.

About the only real difficulties are the problems of focusing and of setting camera and flash controls in the dark. If possible, have a human subject point a flashlight at the camera (or hold a match), and focus on that small, bright light. The same flashlight can be used by the photographer to compose the shot. It's also possible to focus using the distance scale on the lens barrel. For this and other operations with the flash and camera controls, a small flashlight is most useful.

You'll appreciate the help at night if you mount your camera on a tripod and attach a cable release. The steady support becomes an absolute necessity when you make multiple exposures or paint with flash.

Exposure

If the subject is small in relation to the overall scene, automatic flash sensors may cause overexposure. If you can, conduct some exposure tests. Otherwise, bracket by closing the lens down 1/2 to 1 full stop less than called for by the setting on the flash unit's automatic sensor. (With a dedicated flash, activate the underexpose control on the camera, if it is so equipped.)

On the other hand, manual guide numbers are usually based on proper exposure for an average room. Outdoors, results may be slightly underexposed. Again, do a test, or bracket by giving at least 1/2 stop additional exposure.

Outdoors at night you'll find a perfect studio setting, with few or no distractions. A fairly close subject will stand out as if posed on black seamless paper. An automatic flash unit will provide good exposure for nearby subjects. Increase exposure by 1/2 to 1 full stop for a manual flash unit by using a larger aperture.

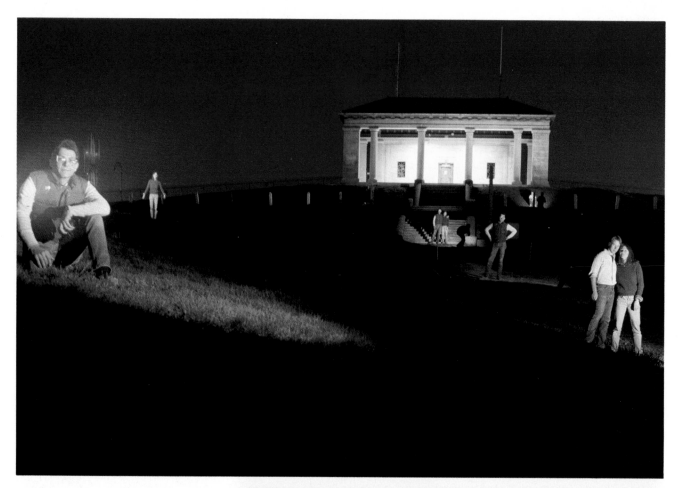

This photographer enlisted the aid of several friends to make a multiple flash photograph with a single flash unit. One friend held the camera shutter open, but covered the lens between flashes. Other friends placed themselves in locations that were compositionally agreeable. The photographer fired the flash manually at each person from a nearby position that wouldn't trap his silhouette between flash and camera. The building in the background was illuminated by firing the flash several times from different spots near the facade.

For this unusual scene, the photographer made a time exposure that showed star trails and features of the house. A confederate fired a flash unit inside the house on signal to illuminate the windows.

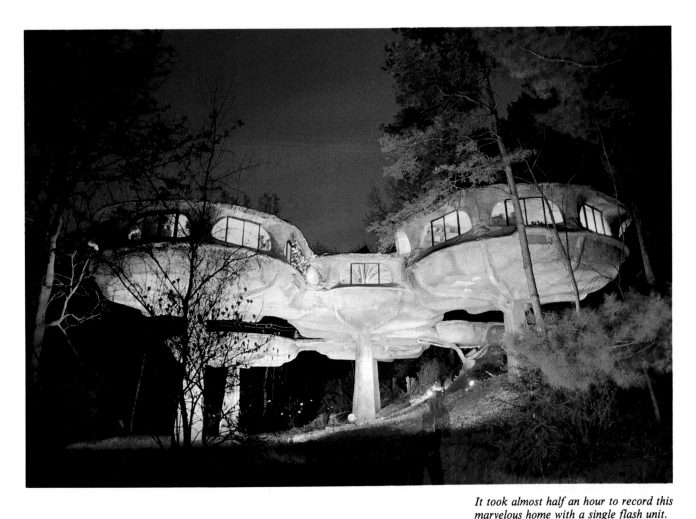

It took almost half an hour to record this marvelous home with a single flash unit. An assistant covered the lens between flashes. Because of the many flashes required, the photographer was careful not to overlap the light beams which would have resulted in uneven exposure.

PAINTING WITH LIGHT

A tiny flash can be used to light a huge area if the subject is stationary or outdoors on a very dark night *or* the camera has the ability to make accurate multiple exposures on the same frame, and you have lots of time and patience.

The camera must be on a sturdy tripod. Each blast of light from the flash covers one small area of the scene—a little practice helps prevent overlap. However, you must be careful to position yourself and the flash so that neither blocks any part of the scene from the camera. If your camera can't make accurate multiple exposures, have an assistant hold a dark card or hat over the lens between flashes. The shutter will remain open on the B or T setting throughout the full series of flashes.

Operate the flash in manual mode, and position it the same distance from the subject for each shot. Dividing the guide number for that distance provides the correct lens aperture. (Overlap, incidentally, causes overexposure, whereas underlap creates dark spots between the areas lighted by flash).

FLASH AND FILTERS

Overall subtle or strong colors can be added to a scene by placing colored filters either over the camera lens or flash head. Though glass or optical-quality gelatin filters are required in front of the lens, considerably less expensive acetate theatrical or photographic color printing CP filters can be taped over the flash. Additionally, many flash manufacturers offer inexpensive color filter kits to fit their flash heads.

Unusual, even bizarre effects are possible when filters are used in conjunction with fill-in flash. One can put a filter on the flash only, or filter both the flash and the lens. Painting-with-light techniques also offer the opportunity to change color with each firing of the flash. Accompanying illustrations demonstrate some possibilities.

Tape a filter over your flash for unusual renditions of familiar subjects.

COMPLEMENTARY COLORS

Use the color wheel pictured above to choose complementary filters to attach to your camera lens and flash head as shown below. Select a color for lens or flash and then find its complement on the opposite side of the color wheel above.

You can also use complementary-colored filters over lens and flash to get normal colors when working with fluorescent lights. Normally fluorescent lighting gives a green tinge to photos and is corrected by putting a magenta-colored filter over the lens. To balance the neutral light from the flash with the fluorescent lights, the flash must be filtered to match the slight green tinge of fluorescent lights. Here a CC30G (green) filter was attached over the flash and a CC30M over the lens. And voila, the picture is color balanced, and the flash nicely lit the worker.

A white horse can become a pallet for your filter collection when you filter fill-in flash. The background, unaffected by the flash, remains perfectly normal.

Attaching complementary filters to flash and lens will give normal color rendition to the flash subject, while allowing the background to be influenced only by the filter attached to the lens. In this case a CC50 magenta filter was used on the flash and its complement, a CC50 green filter was used on the camera lens.

Close-up flash photography

When you move very close to a subject, you'll often find that you want very small apertures for maximum depth of field. Since small subjects can move as fast as larger ones, you'll also want action-stopping capability. Naturally, it helps to be in a position to control the illumination—not always possible with existing-light photography. Electronic flash can solve your dilemma.

An extreme example of close-up photography. The small object d'art is shown next to a same-size slide portrait. This is a 1:1 reproduction ratio, where the image on film is the same size as the object photographed.

Frequently the technical problems encountered in close-up photography strongly recommend electronic flash as the primary source of illumination. Shallow depth of field, an inescapable fact of life when focusing close, requires apertures of $f/11$, $f/16$, or smaller. Such tiny lens openings, in turn, demand slow shutter speeds. But high image magnification leads to corresponding magnification of the slightest camera vibration or subject motion, and slow shutter speeds aggravate the situation. Electronic flash, however, provides more-than-sufficient intensity for close-up subjects at the smallest apertures, and its short duration arrests all but the most severe motion.

CLOSE-UP FLASH EQUIPMENT

Most camera-mounted flash units generate a burst of light whose intensity and beam direction is appropriate for subjects typically 3–20 feet from the flash. However, close-up photography requires camera-to-subject distances that are often only 4–24 *inches*. Nevertheless, you can use your regular flash for close-up work, but special handling is required to avoid overexposure and uneven illumination.

Overexposure can be avoided in various ways: 1) use very small lens aperture, 2) place a diffuser, wide-angle attachment or neutral density filter on the flash, 3) use film with a low ISO speed, 4) hold the flash further from the subject, 5) use bounce flash, 6) decrease the power of the flash if such control is available, and 7) use small, low-power flash units or special close-up flash equipment such as a ring flash. More discussion of these points follows later in this chapter.

The potential for uneven illumination exists when a standard flash is mounted on the camera and used for close-up photography. With the subject very close to the lens, the flash head is proportionally quite high above the subject and the flash beam does not have a long path over which to spread out. This can lead to inadequate illumination of the lower portion of a scene or, when very close, the beam may pass above the entire subject, missing it completely!

Proper illumination, then, usually requires that the flash be removed from the camera body and placed more on line with the subject, either by hand-holding the flash, or using

As your camera moves closer to the subject, a conventional camera-mounted flash tends to aim its light above the lens axis. This effect can be seen in the upper photo, although it is not too severe since the camera was only moderately close.

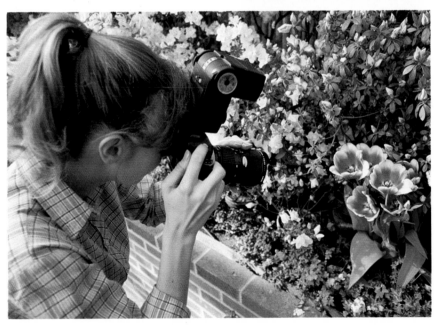

one of the specially-designed brackets for close-up flash. Alternatively, ring flash units may be used (see next page), or a conventional flash can be bounced off a white cardboard.

Often, a longer-than-normal focal length lens will be useful since it will produce a longer camera-to-subject distance. This, in turn, provides more distance for the flash to spread out and illuminate the subject evenly.

Some flash units allow the flash head to be tilted downward so that the light beam will be accurately aimed at the subject when photographing close up. Or, you can tilt any flash with an accessory tilting adapter that slides into the camera's flash shoe.

A number of companies make special brackets that facilitate accurate positioning of flash units for close-up photography. Because of the physical constraints of lens and subject position, the flash illumination often must come from the side. To prevent one-sided illumination, a second flash from the opposite side is frequently used. To add some character to the illumination and shape to the subject, one of the two flash units can be placed farther away, used at lower power, or covered with diffusion material (as shown here). These techniques prevent the light from being too even and dull.

Small, inexpensive low-power flash units are ideal for these close-up applications because their light output typically requires apertures around f/11-f/32 with film speeds of ISO 25-100. Additionally their light weight makes them easy to manipulate on close-up brackets, and their small size prevents interference with the subject. For direct flash photography, a unit having a guide number of 50-80 for a film speed of ISO 100 is ideal. For consistent results in close-up work with automatic units that cannot be switched to manual, place a piece of black tape over the sensor so it doesn't influence exposure. With tape in place, an automatic unit is effectively transformed into a manual unit.

Left, With a little practice, excellent close-up photographs can be taken by hand-holding your flash near the subject. This technique permits quick placement of the flash at virtually any angle. Here, automatic flash exposure systems are particularly advantageous. Focusing is achieved by setting the lens to the appropriate magnification, then moving the camera forward and backward until sharp focus is seen in the viewfinder. The short flash duration will freeze any camera motion.

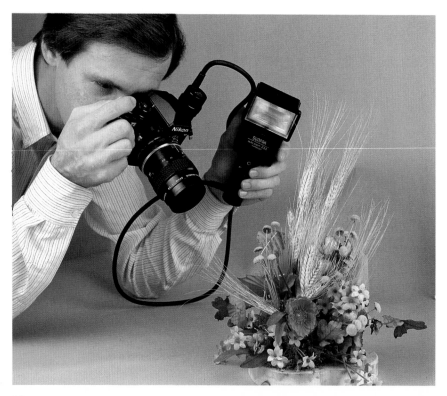

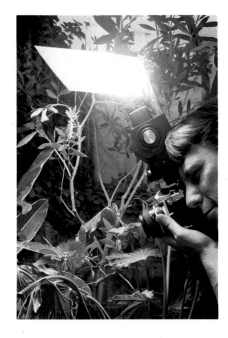

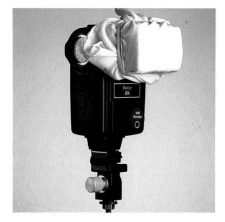

Getting close with a macro lens will often mean that you will have to reduce the output of your flash to prevent overexposure. (This is true even of moderately powerful units—those with guide numbers greater than 80 for ISO 100 film). One good way to reduce the intensity of the light at the subject is to bounce the flash off a white card. The bounce flash also provides much softer, often more attractive light than direct flash.

Most medium-size and larger, shoe-mounted flash units are too powerful to use less than 2 ft from the subject. To decrease their brightness for close-up photography, place one or two layers of a handkerchief or tracing paper over the flash head. Through-the-lens automatic flash exposure systems will continue to operate properly; no change in settings is required. With manual flash, a flash meter or exposure tests will be required (see p. 89). Automatic systems that have a sensor on the flash are best used in their manual mode for very close-up photography, with exposure determined as explained on page 89.

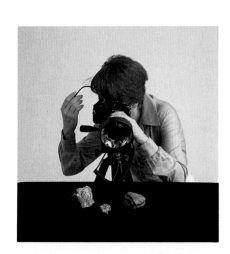

Ring flash units for close-up photography screw onto a camera like a filter. The donut-shaped flash tube surrounds, and is very close to, the lens axis, creating very even, almost shadowless illumination.

Such light quality is often desirable for scientific, medical and forensic work. Also, since the flash is fixed right on the lens, no angular adjustment is required, regardless of subject distance; therefore ring flash is very convenient for field work. The light is very predictable, repeatable, and uniform.

An accessory light sensor available with some flash units can be aimed at the subject to obtain correct exposure.

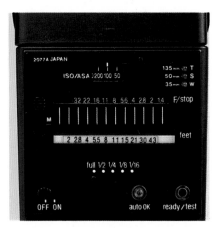

Flash units with a variable-power setting work well for close-ups because their power can be lowered to a level that yields appropriate exposure and uses less energy.

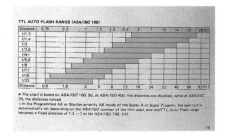

At close distances, dedicated TTL flash units cannot be used on any aperture. Instead they must be set to a very small aperture, such as f/16, that will depend on the distance. Consult your flash manual to see which small apertures can be used at close distances for your TTL flash.

To photograph this newt, the photographer used 45° sidelighting with two small flash units.

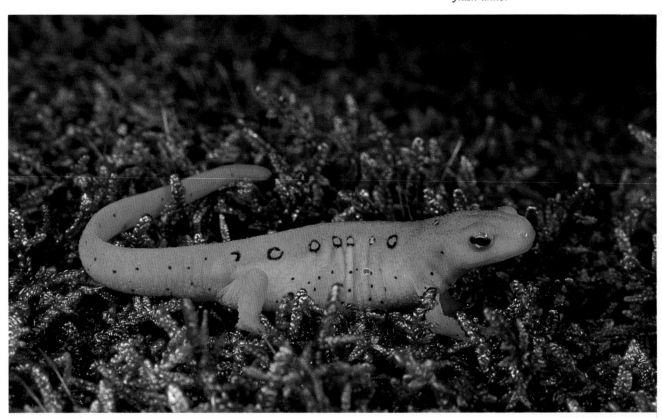

EXPOSURE TEST

1. Place the camera on a tripod and the subject—which should be medium-toned—in a fixed position.

2. Load the camera with your standard film and place the flash in whatever position is required to obtain the desired lighting effect. (In close-up work, aim the flash very carefully!)

3. If the flash will be used in its automatic mode, be certain the minimum flash-to-subject distance is not violated (don't hesitate to move the flash back and away from the camera). However, with bounce or diffused flash and a remote sensor near the lens, the unit can usually be placed 25 to 50% closer than the minimum recommended distance.

4. Now make a series of bracketed exposures at various lens-to-subject distances. Bracket by full stops.

 For example, with an automatic flash, start at the aperture recommended on the calculator dial, say *f*/8. With a measured 20-inch lens-to-subject distance, make exposures at *f*/32*, *f*/22*, *f*/16, *f*/11, *f*/8, *f*/5.6 and *f*/4. Next, move the camera so the lens-to-subject distance is 15 inches. Focus and make the same series of exposures. Continue toward the subject in 5-inch increments until the lens will focus no closer.

 *If possible

To find a starting aperture at each magnification for bracketing with a manual flash, divide the guide number by the accurately measured flash-to-subject distance. (Since most guide numbers are calculated using distances in feet, flash-to-subject distance must be measured in feet.)

In all cases, take careful notes on exposures and physical placement of flash and lens. Some methodical photographers place a small card with all applicable data in the scene (if it fits), so that a numbering mistake by the processing lab won't harm the test.

5. Process the film normally, then carefully examine the negatives (not prints) or slides. Record the best exposure for each lens-to-subject distance, and make a small chart to tape onto the flash. (The best exposure may fall between the full-stop brackets.)

 From now on, use that chart of lens-to-subject distance vs aperture for all close-up photography using the same lens, film, flash, and flash position.

 While the test does take some time, you can work very quickly and very accurately once the chart is made.

Close-Up Exposure with Flash Meters

Flash meters (see pages 59 and 60) are particularly useful for close-up photography because, as we mentioned before, it is frequently not possible to use a flash in its automatic mode, and manual close-up flash calculations may be complicated.

When no exposure compensation is required for lens extension, the reading provided by the meter can be used directly. Such situations include the use of close-focusing zoom lenses, some internally focusing macro lenses, and any nonclose-up lens to which supplementary close-up lenses have been added.

Use of extension tubes, bellows, or most conventional macro lenses *requires a correction to the flash meter's suggested aperture* (f_m). First, determine the magnification (**M**) by dividing the short dimension of the scene into the short dimension of the film frame (1 inch for 35 mm film).

Alternatively, **M** is often indicated on a macro lens' focusing scale in terms of the *magnification ratio,* **R**, and appears as 1:**R**.

$$\mathbf{M} = 1/\mathbf{R}$$

so if the lens scale indicates 1:4,

$$\mathbf{M} = 1/4 = 0.25, \text{ or at } 1{:}3,$$
$$\mathbf{M} = 0.33.$$

Once you have the meter reading (fm), the correct aperture (fc) to set on the lens is simply

$$f_c = \frac{f_m}{M + 1}$$

For example, say the lens scale indicated **R** = 1:2; therefore **M** = 0.5. Without a lens scale, the short dimension of the scene would be 2 inches high, and dividing that into the short dimension of the 35 mm film (again, it's 1 inch) also equals 0.5. So if the meter recommends, say, *f*/22, you'll have to actually use an aperture of

$$fc = \frac{22}{0.5+1} = f/15$$

(effectively the same as f/16).

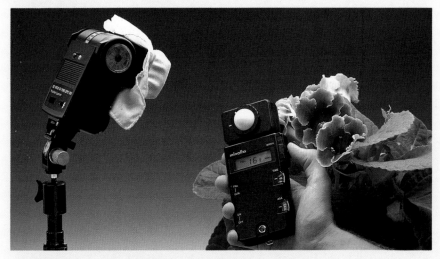

Automatic sensors on the flash generally cannot be used to provide correct exposure in close-up photography. Flash meters offer a start for calculating the required aperture. With true macro lenses, take a flash meter reading and then apply the formula at right to the aperture readout on the meter. The formula gives the correct aperture to set on the lens.

Freezing motion

Because the longest duration of an electronic flash is typically 1/1000 second (as fast as many cameras' fastest shutter speed), you'll find that electronic flash can capture images of fast-moving subjects that even your eye cannot provide. Some units with auto or power control capability may even provide a flash as short as 1/30,000 second—an excellent speed for recording the very quick.

The ultimate in high-speed flash photography—a small missile pierces a light bulb in a matter of milliseconds. This is probably not possible for most flash photographers, but there are dozens of other exciting motion-stopping opportunities, as you'll see in the next few pages.

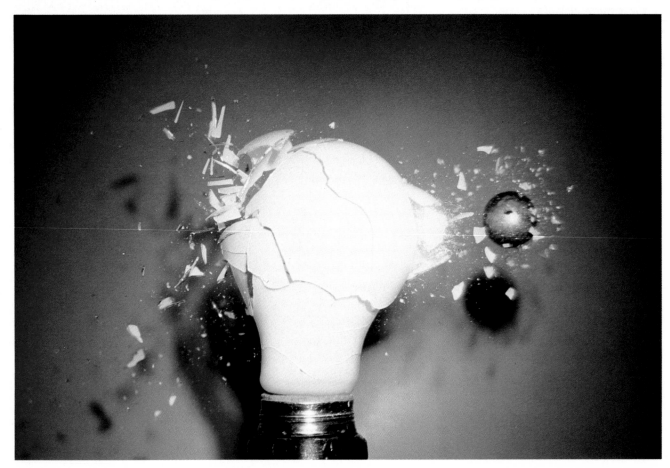

It is quite easy to create striking, informative, and beautiful images by capitalizing on the short, motion-stopping duration of electronic flash. Though the shutter speed on most focal-plane-shutter cameras must be set at around 1/60 second to properly synchronize with flash, the actual exposure time of the image on the film is governed by the burst of light from the flash, typically 1/1000 second.

In fact, 1/1000 second is the *longest* duration for most camera-mounted units and occurs when fired at maximum output. At lower output settings, you'll find that flash durations of 1/10,000, 1/20,000 and sometimes even 1/50,000 second are available, the shortest burst occurring at the minimum output. (The brightness of the flash remains the same at any output setting—only the duration of the flash changes.)

Flash duration can be regulated by either using the variable power control on the flash, if it is so equipped, or by placing the subject close to a flash operating in the automatic mode. In the second case, the closer the subject (up to the near limit permitted by the automatic sensor) and the larger the aperture, the shorter the duration.

It is obvious that only small scenes close to the camera can be photographed at the shortest duration, since power output governs duration. But frequently 1/10,000 second or so is more than adequate to arrest some types of animal or human motion. This flash speed can usually be achieved if the scene covers an area about 8 by 12 feet and if an automatic flash is set at its largest aperture mode. Higher speed films, such as KODACOLOR VR 400, are useful here to obtain adequate depth of field.

Of course, larger areas can be illuminated by using a number of flash units set on low power, all triggered simultaneously by slave cells. (For most purposes, assume that slave cells have no delay which could cause a problem with high speed subjects (see page 65). A flash meter can help you determine exposure.

It's easy to freeze most human or animal motion with an automatic flash unit, a dark background, a high-speed film, a large aperture, practice, and anticipation.

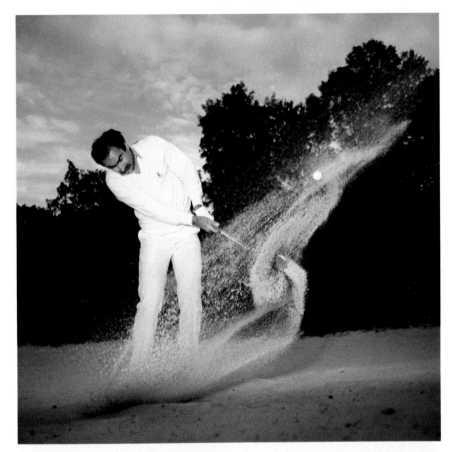

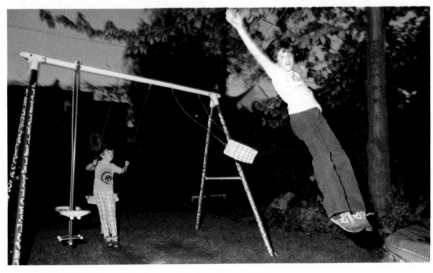

Triggering

Photographing a spinning electric fan or a pirouetting ballerina requires no special triggering—look through the viewfinder and fire when appropriate. Anticipating the "decisive move-ment" slightly is helpful, since there is a delay caused by our relatively slow human reflexes and by the mechanical delays in the camera.

Other subjects—flying insects, dropping projectiles, racing rodents —are moving so rapidly past the camera that the flash must be electrically or mechanically triggered at the exact instant the subject moves in front of the lens. And since the camera shutter takes too long to open, these events must be staged and photographed in a totally dark room with the shutter locked open. The brief flash acts as the shutter.

Any flash can be fired by electrically connecting the two wires (or their extension) found inside the PC cord. This is called contact closure. Anyone familiar with basic electronics (ham radio operators, TV repairpersons, appliance technicians) can devise a flash trigger appropriate for the event from a relay activated by a trip wire, microphone signal, broken light beam, or even a light touch. However, no one but authorized flash technicians should attempt to work on the *inside* of a flash unit—**severe shock hazards can result!**

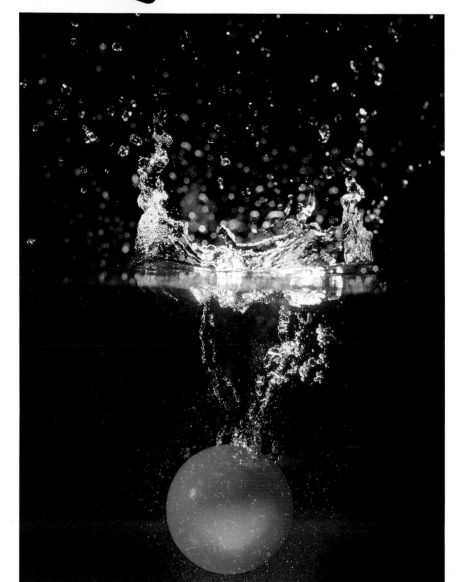

The sound trigger shown above would help to record the exact moment of impact of the rubber ball striking the water seen at right. Without a sound trigger or photoelectric cell you'll want to practice before exposing any film. Try to synchronize the action with pressing the shutter release or firing the flash manually.

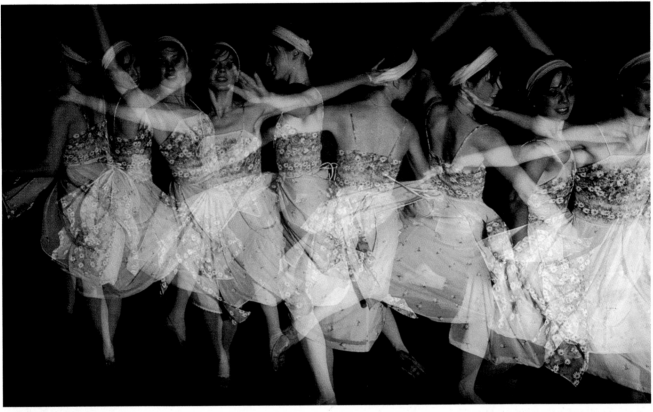

STROBOSCOPIC EFFECTS

Stroboscopes are electronic flash units that give a repetitive series of short-duration flashes. Though most people are familiar with the simple stroboscopes used to create psychedelic effects in discos, there are lesser known models designed for photography that have controls to vary repetition rates, and sometimes even light intensity.*

To achieve satisfactory results, considerable patience and trial-and-error tests are required to find the perfect repetition rate and to coordinate the beginning and end of the sequence. (Instant-film tests can be extremely helpful.)

This work also requires a totally dark room with a black felt backdrop. And, of course, lock the shutter open for the full duration of the sequence.

Balance the effects of exposure on parts of the subject that receive repetitive flashes and parts of the subject

receive only one flash in each position. Areas receiving repeated flash illumination probably will be a bit overexposed (the effects are cumulative) and areas that get only one flash will be a bit underexposed.

*Some manufacturers and distributors of stroboscopic equipment appropriate for photographic applications are given below. Kodak does not endorse the products sold or manufactured by the organizations shown in this incomplete list.

Wein Products, Inc.
115 West 25th Street
Los Angeles, CA 90007

Edmund Scientific Corp.
101 East Gloucester Pike
Barrington, NJ 08007

Times Square Theatrical Supply Co.
318 West 47th Street
New York, NY 10036

and in the U.K.:
Pulsar Light of Cambridge Limited
Henley Road
Cambridge CB1 3EA
England

By setting an automatic flash unit to the autowinder mode and using fast film with a large aperture, the photographer made this motion study of a dancer. The low power setting made it possible to fire the flash rapidly many times while keeping the shutter open. Needless to say, the background was extremely dark to avoid ghost imaging from the ambient lighting.

APPENDIX

ENERGY

Batteries are relied upon almost exclusively as the primary sources of energy for portable flash equipment. Modern batteries are remarkable in their capabilities, yet due to improper use, selection, or user awareness of capacity, battery failure is the most common cause of flash equipment malfunction.

BATTERIES INSIDE THE FLASH

Disposable Batteries

Typically two or four AA- or C-size cells comprise the self-contained energy source for a camera- or handle-mounted flash. For occasional use, disposable batteries are most convenient, least expensive, and most reliable. Flash requires *alkaline* batteries, *not* the low-power carbon-zinc cells. Alkaline batteries warn of impending exhaustion by causing flash recycle time to increase, but since there is no way of measuring the remaining amount of power in a battery (even if it tests "OK" on a battery meter), always carry fresh, spare batteries. Never keep any type of battery inside the flash for long term storage, and before inserting batteries it's a good idea to clean both ends of the batteries and the contacts inside the battery compartment with a pencil eraser. To prolong shelf life, store batteries in a refrigerator (not freezer); keep them in a plastic bag and allow them to warm up before use.

Kodak provides a line of high-quality batteries that fit many flash units and cameras. The terminals are coated with real gold to provide superior conductivity and corrosion resistance.

Rechargeable Batteries

Disposable batteries become expensive when doing a lot of flash photography, and they also produce the slowest recycle time of all battery types. Rechargeable batteries eliminate those shortcomings, but to gain their potential benefits, they do require special attention. Rechargeable batteries that fit inside a flash are invariably nickle-cadmium (called "NiCad") type. The following guidelines are important:

1. NiCads should be *fully discharged before charging*. If your photography has not fully depleted the batteries, continue to fire the flash (put it in *MANUAL* mode or cover the sensor with your finger) until recycle time is at least one minute (let the flash cool for a few minutes after every 8–10 pops). Failure to do this will result in far fewer flashes per charge than the batteries are supposed to deliver.

Rechargeable NiCad batteries can be substituted for disposable alkaline cells when greater economy and faster flash recycle time are required. However, NiCads must be maintained properly or they will give disappointing results.

2. Rechargeable NiCad batteries require periodic use and charging. Fire the flash every month or two, fully discharge the batteries, then recharge. Store in a fully charged condition.

3. If discharged too much, some rechargeable batteries may never again hold a charge. When recycling time becomes twice normal, recharge the batteries.

4. If your charger provides a fast/slow charge option, slow charging somewhat prolongs battery life. However, not all batteries can be quick-charged; check the battery manufacturer's instructions. Never attempt to recharge disposable batteries; they may explode!

5. Rechargeable batteries provide about half as many flashes per charge as do fresh disposable batteries of like size.

Additionally NiCads provide no warning before they "die." Therefore, it is strongly advisable to keep at least two charged spare sets on hand. In storage, NiCads loose about 1% of their charge per day, so after a few weeks of sitting around they are not very useful; you will probably want to fully discharge, then charge them before use.

6. Carefully read the instructions provided by the manufacturers of your batteries and charger!

EXTERNAL BATTERY PACKS

A boon to the photographer doing extensive flash photography is the high-capacity external pack. In addition to hundreds, even thousands of flashes per charge, they provide consistently fast recycling time, at a very low cost per flash (after initial investment). Worn on the belt or slung over the shoulder, the battery pack is connected to the flash by a somewhat inconvenient coiled power cord.

Like small batteries that fit inside a flash, external packs use either disposable or rechargeable batteries. Some flash manufacturers make external packs that hold C- or D-size batteries (you can use disposable or rechargeable cells).

The latest in external battery technology is the so-called gel-cell battery. Gel-cells recycle a flash even faster than NiCad batteries, and can be recharged scores, even hundreds of times. Additionally, gel-cells do *not*

External gel-cell packs are extremely convenient and reliable sources of rechargeable battery power. Their electrical characteristics make them far less "fussy" to maintain than NiCads. Gel-call packs are available to fit all but the smallest portable flash units.

This photographer is wearing a 510-volt external battery pack. In his hand is the disposable battery that provides hundreds of full-power flashes at extremely fast recycle times. Such a system is ideal for extensive flash photography in locations where batteries cannot be recharged.

require discharging prior to recharging, they discharge very little in storage, and are far less prone to damage than are NiCads due to overcharging or deep discharging. Gel-cells can also be "topped off" with a quick charge prior to a big photography project, and usually have indicator lights signaling amount of remaining charge. Like all rechargeable batteries, studiously follow manufacturers directions, and do not leave batteries—of any type—in the heat.

A third variety of external pack, high-voltage (usually 510 volts) packs offer the ultimate in flash recycling time: typically one second or less after full flash output, and only a fraction of a second when the flash is in automatic mode and requires only partial power. 510-volt batteries come in disposable or rechargeable NiCad types, but 510-volt packs are only available for professional-level flash equipment.

AC Operation When you want to take many flash photographs in a fixed location for studio, portrait, scientific, or industrial applications, a more convenient, less expensive, and frequently more reliable alternative to batteries is the ac adapter. Available for all but the least expensive flash units, these small transformers convert wall-outlet current to the voltage required by the flash equipment.

An ac adapter usually provides a recycling rate similar to that offered by alkaline batteries. This inexhaustible source of power, however, may tempt one to fire the unit at full power in rapid succession for long periods of time. Such abuse will frequently cause the flash to overheat and then fail altogether. Although some equipment can handle 50 full-power flashes at 10-second intervals, other units will overheat after 20 shots. Consult the manufacturer about such heavy-duty operation.

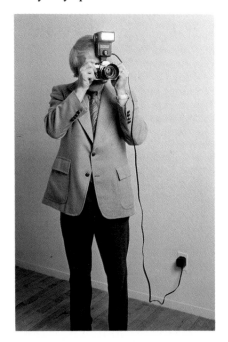

Maintaining the Flash Capacitor You recognize the need to remove flash batteries during storage and to charge rechargeable cells periodically, even if not being used. Similar periodic attention must be devoted to maintaining the flash capacitor which, if unused for a number of months, loses its ability to hold a charge effectively.

The simple procedure required to bring the capacitor to peak operating efficiency is called **reforming the capacitor.**

1. Set the flash for full-power manual operation.
2. Install batteries known to be in satisfactory condition. To save battery life or eliminate the need to purchase fresh batteries, an ac adapter is excellent for this application and so are rechargeable batteries.
3. Turn the unit on and wait 5 minutes.
4. After 5 minutes, fire the flash six to eight times, waiting between flashes doubles the time it takes to recycle (as indicated by the ready light).
5. Let the capacitor charge fully before storage. Reform the capacitor at least every three months to ensure that it will continue to deliver maximum power and minimum recycle time. It might help to jot down some dates on your calendar.

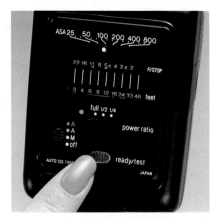

Index

METRIC DISTANCE EQUIVALENTS

If you know:	Multiply by:	To get:
inches	25.4	millimetres
	2.54	centimetres
	0.0254	metres
feet	304.8	millimetres
	30.48	centimetres
	0.3048	metres
yards	91.44	centimetres
	0.9144	metres
miles	1.60934	kilometres